T0031667

# BEGINNER'S GUIDE TO DRAWING
# MANGA FACES, HEADS, AND HAIR

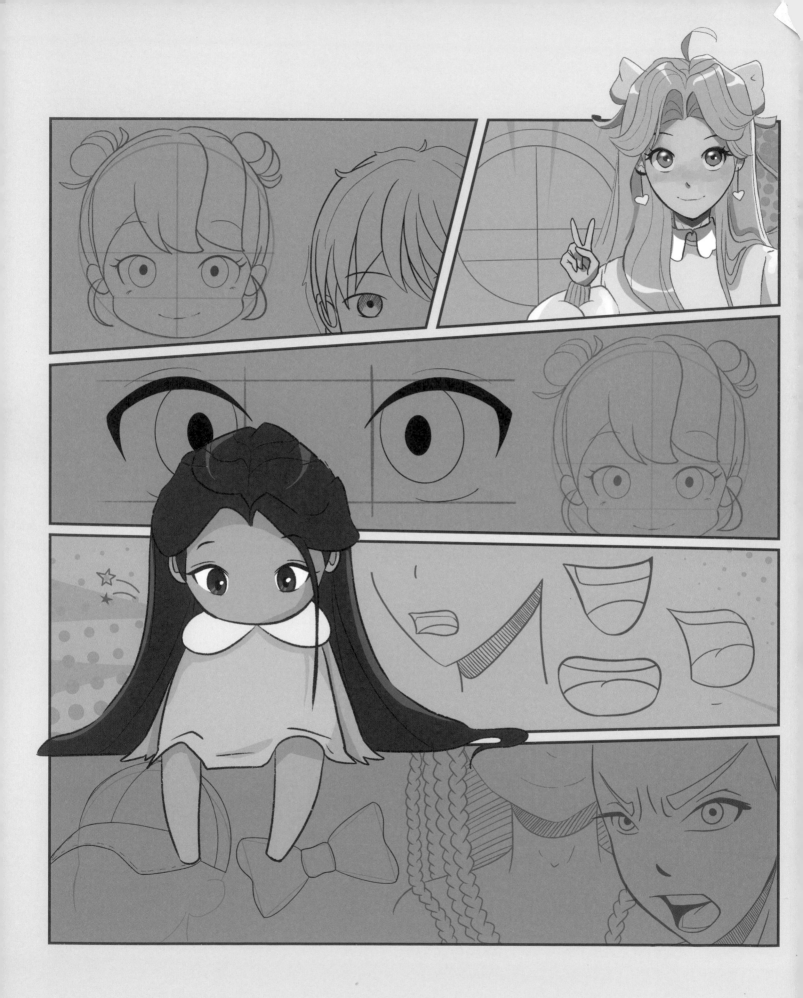

# BEGINNER'S GUIDE TO DRAWING MANGA FACES, HEADS, AND HAIR

CÉLINE CRESSWELL

## DESIGN ORIGINALS

an Imprint of Fox Chapel Publishing

www.d-originals.com

A QUARTO BOOK

ISBN: 978-1-4972-0656-4

COPY PERMISSION: The written instructions,
photographs, and projects in this publication are intended
for the personal use of the reader and may be reproduced for
that purpose only. Any other use, especially commercial use,
is forbidden under law without the written permission of the
copyright holder. Every effort has been made to ensure that all
information in this book is accurate. However, due to differing
conditions, tools, and individual skills, neither the author nor
publisher can be responsible for any injuries, losses, or other
damages which may result from the use of the information in
this book.

INFORMATION: All rights reserved. All images in
this book have been reproduced with the knowledge and
prior consent of the artist concerned and no responsibility is
accepted by producer, publisher, or printer for any
infringement of copyright or otherwise, arising from the
contents of this publication. Every effort has been made to
ensure that credits accurately comply with information
supplied.

Copyright © 2024 Quarto Publishing plc

This edition published in 2024 by New Design Originals
Corporation, www.d-originals.com, an imprint of Fox
Chapel Publishing, 800-457-9112, 903 Square Street,
Mount Joy, PA 17552.

We are always looking for talented authors. To submit
an idea, please send a brief inquiry to acquisitions@
foxchapelpublishing.com.

Conceived, edited, and designed by
Quarto Publishing plc
1 Triptych Place
London SE1 9SH
www.quarto.com

QUAR.1169141

Assistant editor: Ella Whiting
Editorial assistant: Elinor Ward
Managing editor: Lesley Henderson
Designer: Joanna Bettles
Illustrator: Céline Cresswell
Art director: Martina Calvio
Publisher: Lorraine Dickey

Printed in China
First printing

FSC
www.fsc.org
MIX
Paper | Supporting
responsible forestry
FSC® C016973

# Contents

**Find me on Instagram @redpanda_art**

**I would love to see any of your drawings from the book, so feel free to tag or share them with me!**

## Meet Céline

Hi! I'm Céline and I'm an illustrator from the UK.

I love to draw cute characters and bring people's visions to life! With this book, I hope you'll be able to do the same.

My first attempt to learn how to draw characters began with a manga-style book. The result was a book stuffed with scraps of paper covered in manga characters. Over time, some drawings have slipped out and been lost, but I still have the tutorial book with a couple drawings stashed under my bed!

I hope you can use this book to learn something new, draw some awesome characters, and look back on your work in the future to see how far you've come.

Enjoy this journey!

**Céline Cresswell**

# Tools and Materials

You can create your manga characters with any tools you are comfortable with, so pick whatever you prefer! Here are some suggestions of what you might like to use.

**PENCIL**
Sketching the initial drawing in pencil is helpful in case you need to erase things.

**PAPER**
This book gives you space to draw in the book, so you don't need extra paper. But if you want more space, grab any paper you have!

**PEN**
Usually a black ink pen is used for manga. You can use a pen for the entire drawing process or just at the end to finalize or emphasize the shapes.

**ERASER**

**PENCIL SHARPENER**

# About This Book

This book is structured as a series of tutorials paired with spaces where you can practice your drawing skills in the book itself.

The first tutorials help you master some basic facial proportions. Then, you'll explore facial features and expressions and learn how to draw different types and styles of hair. Finally, a "try it yourself" section at the end of the book gives you a chance to use all the skills you've learned so far, to copy example characters and to create your own original characters!

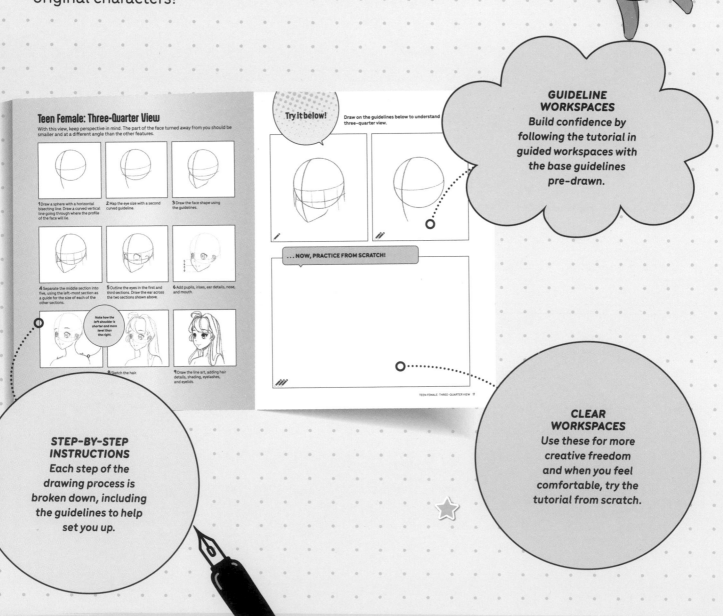

**GUIDELINE WORKSPACES**
Build confidence by following the tutorial in guided workspaces with the base guidelines pre-drawn.

**STEP-BY-STEP INSTRUCTIONS**
Each step of the drawing process is broken down, including the guidelines to help set you up.

**CLEAR WORKSPACES**
Use these for more creative freedom and when you feel comfortable, try the tutorial from scratch.

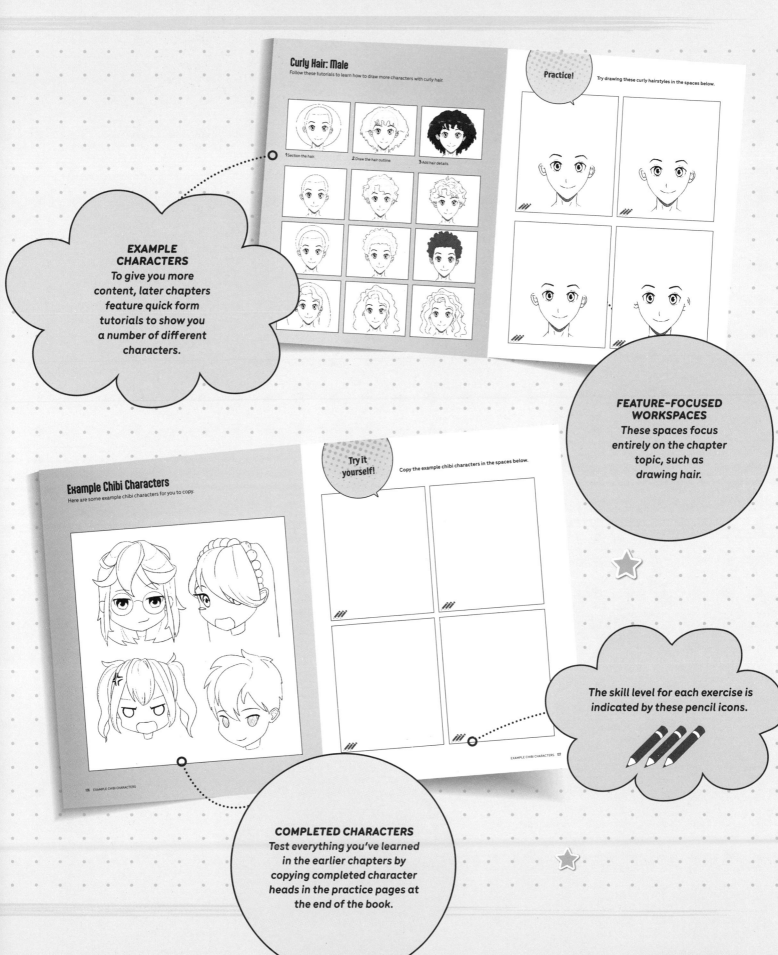

**Curly Hair: Male**
Follow these tutorials to learn how to draw more characters with curly hair.

1 Section the hair.

2 Draw the hair outline.

3 Add hair details.

**Practice!**
Try drawing these curly hairstyles in the spaces below.

**EXAMPLE CHARACTERS**
To give you more content, later chapters feature quick form tutorials to show you a number of different characters.

**FEATURE-FOCUSED WORKSPACES**
These spaces focus entirely on the chapter topic, such as drawing hair.

**Example Chibi Characters**
Here are some example chibi characters for you to copy.

**Try it yourself!**
Copy the example chibi characters in the spaces below.

EXAMPLE CHIBI CHARACTERS 127

EXAMPLE CHIBI CHARACTERS 126

The skill level for each exercise is indicated by these pencil icons.

**COMPLETED CHARACTERS**
Test everything you've learned in the earlier chapters by copying completed character heads in the practice pages at the end of the book.

CHAPTER 1

# Facial Shape and Proportions

There is no one-size-fits-all approach for drawing characters, even in manga. The style will vary with the artist but it is important to understand at least a basic formula or method for drawing facial proportions.

This section goes through some example character types, exploring their facial shapes and proportions in a series of tutorials. Use these as building blocks to create your own proportionally correct characters, or as guidelines if you are stuck when drawing characters.

Arguably the trickiest part of drawing is proportions, so once you have mastered this skill, you'll be on the right track to creating some amazing drawings.

# Teen Female: Front View

Follow this tutorial to learn how to draw a teen girl from a front view.

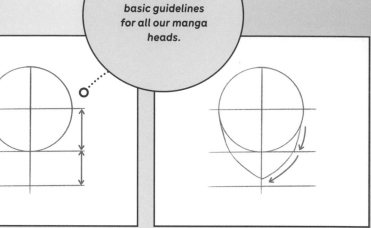

*These are the basic guidelines for all our manga heads.*

**1** Draw a circle with a vertical line through the center.

**2** Draw a horizontal line through the circle center, another at the circle base, and an equally spaced third line.

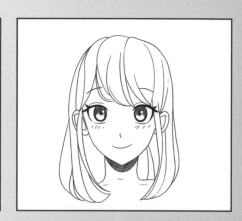

**3** Connect the three lines, ending four-fifths down the second section.

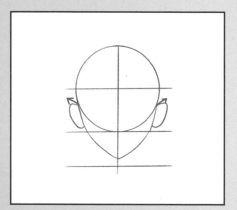

**4** Start drawing the ears from the top, flowing out from where the circle meets the lower face.

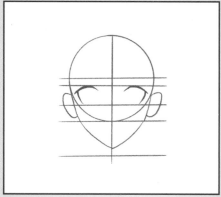

**5** Draw a new horizontal guideline through the center of the ears. Add the eye outlines.

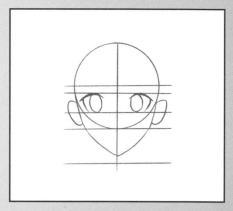

**6** Add elliptical irises.

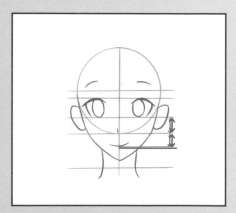

**7** Add the eyebrows, nose, and mouth.

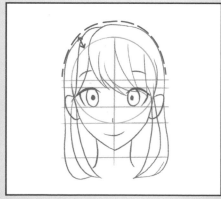

**8** Sketch the hair.

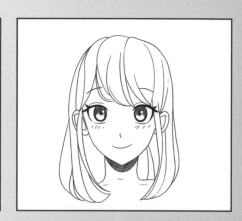

**9** Finish with finer details such as eyelashes, extra strands of hair, and shading.

**Try it yourself!**

Draw over these guidelines to get used to the teen female proportions.

...NOW, TRY FROM SCRATCH!

# Teen Female: Profile View

When drawing a profile view of a teen girl, the hardest part is getting the nose and mouth right, so follow the shapes carefully.

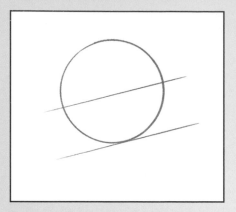

**1** Draw a circle with a line through the center, angled to where the eyes are looking. Draw a second line parallel to this at the circle base.

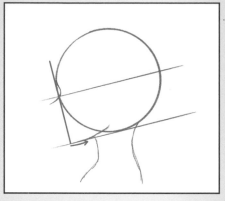

**2** Add the nose bridge, chin, and neck. Use the red line prompts to help you here!

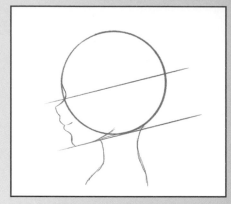

**3** Join the nose bridge to the jaw.

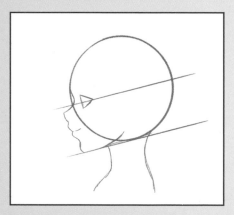

**4** Draw a triangle with a point starting at the center line.

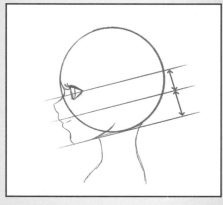

**5** Curve the sides of the triangle slightly. Add irises, lashes, and a new guideline.

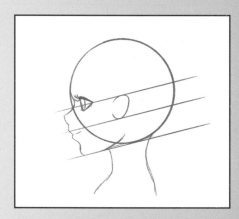

**6** Draw the ear as shown.

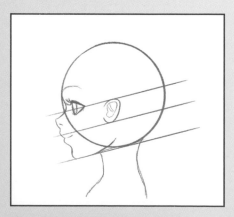

**7** Add the eye details, eyebrow, and nostril.

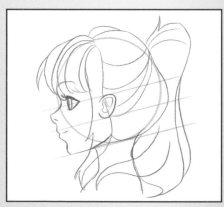

**8** Sketch the hair.

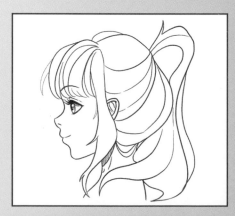

**9** Draw the line art, adding hair details, shading, and an eyelid.

# Practice!

First, use the guidelines to understand the female profile view.

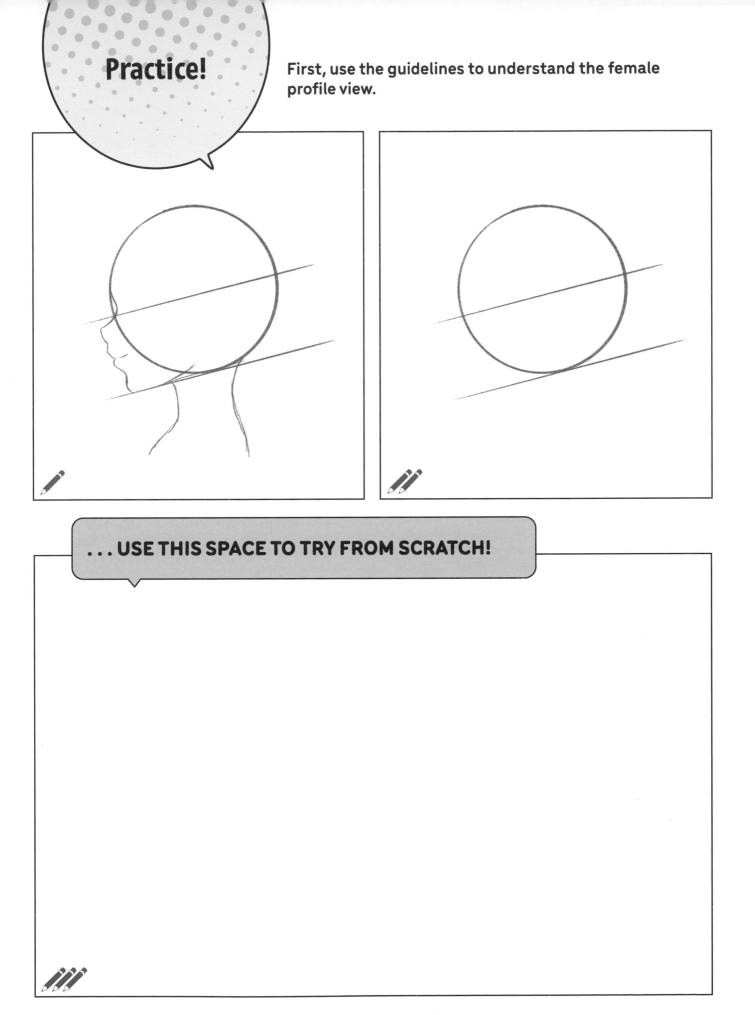

. . . USE THIS SPACE TO TRY FROM SCRATCH!

# Teen Female: Three-Quarter View

With this view, keep perspective in mind. The part of the face turned away from you should be smaller and at a different angle than the other features.

**1** Draw a sphere with a horizontal bisecting line. Draw a curved vertical line going through where the profile of the face will lie.

**2** Map the eye size with a second curved guideline.

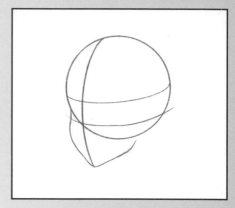

**3** Draw the face shape using the guidelines.

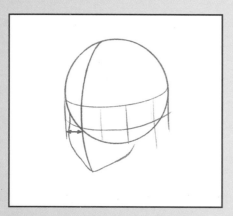

**4** Separate the middle section into five, using the left-most section as a guide for the size of each of the other sections.

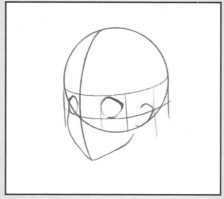

**5** Outline the eyes in the first and third sections. Draw the ear across the two sections shown above.

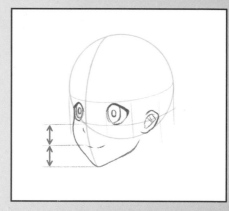

**6** Add pupils, irises, ear details, nose, and mouth.

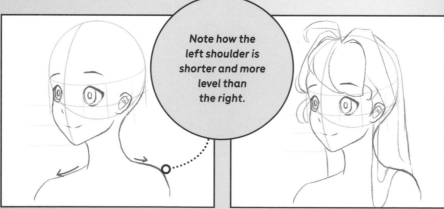

*Note how the left shoulder is shorter and more level than the right.*

**7** Add the eyebrows, neck, and shoulders.

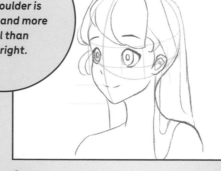

**8** Sketch the hair.

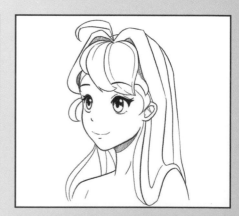

**9** Draw the line art, adding hair details, shading, eyelashes, and eyelids.

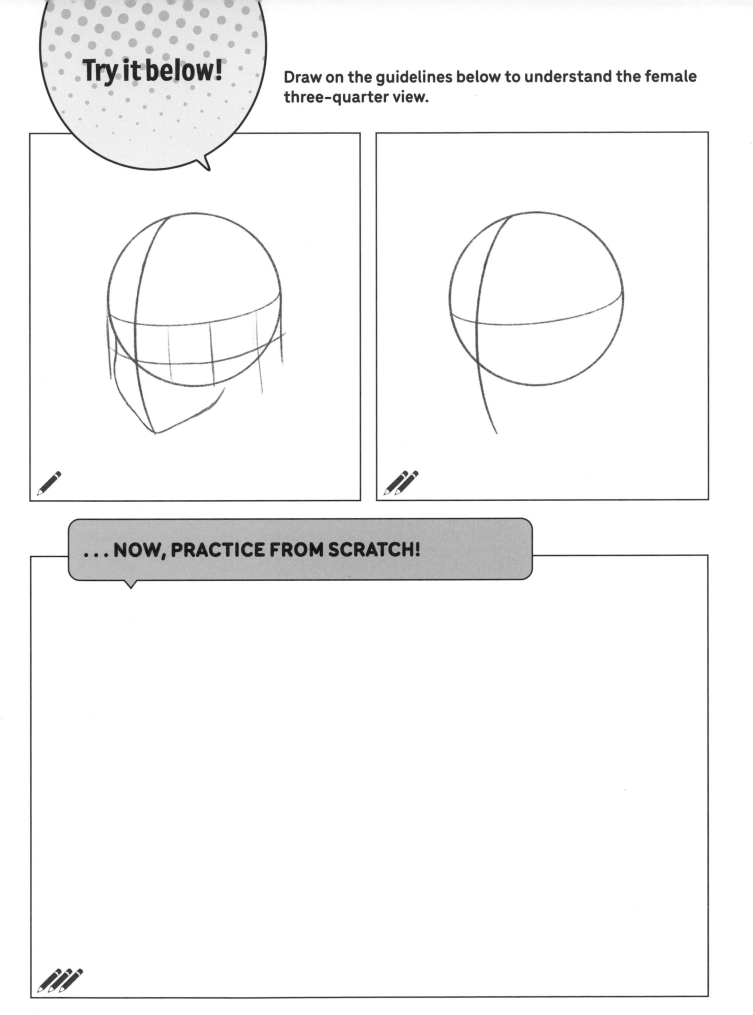

**Try it below!**

Draw on the guidelines below to understand the female three-quarter view.

. . . NOW, PRACTICE FROM SCRATCH!

# Teen Male: Front View

This tutorial helps you spot subtle differences between male and female facial shapes and features.

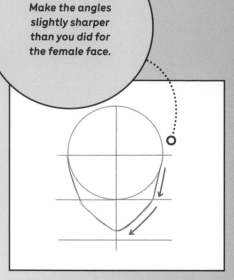

*Make the angles slightly sharper than you did for the female face.*

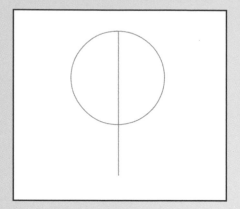

**1** Draw a circle with a vertical line through the center.

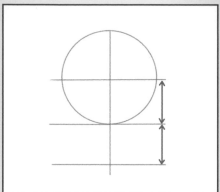

**2** Draw a horizontal line through the circle center, another at the circle base, and an equally spaced third line.

**3** Connect the three lines, ending four-fifths down the second section.

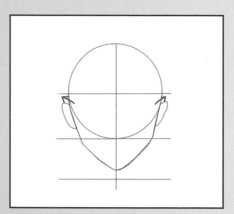

**4** Start drawing the ears from the top, flowing out from where the circle meets the lower face.

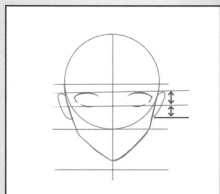

**5** Draw a new horizontal guideline through the center of the ears. Add the eye outlines.

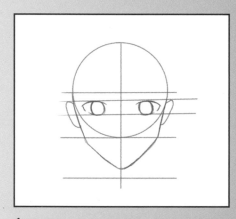

**6** Add irises.

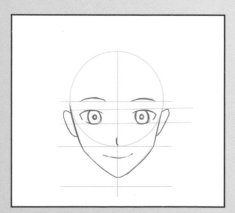

**7** Add the eyebrows, nose, and mouth.

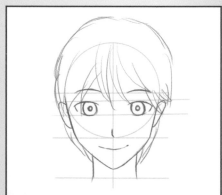

**8** Sketch the hair.

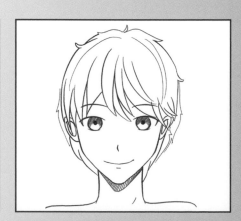

**9** Finish with finer line art details like extra strands of hair and shading.

# Try it yourself!

First, use the guidelines below to practice drawing teen male facial proportions.

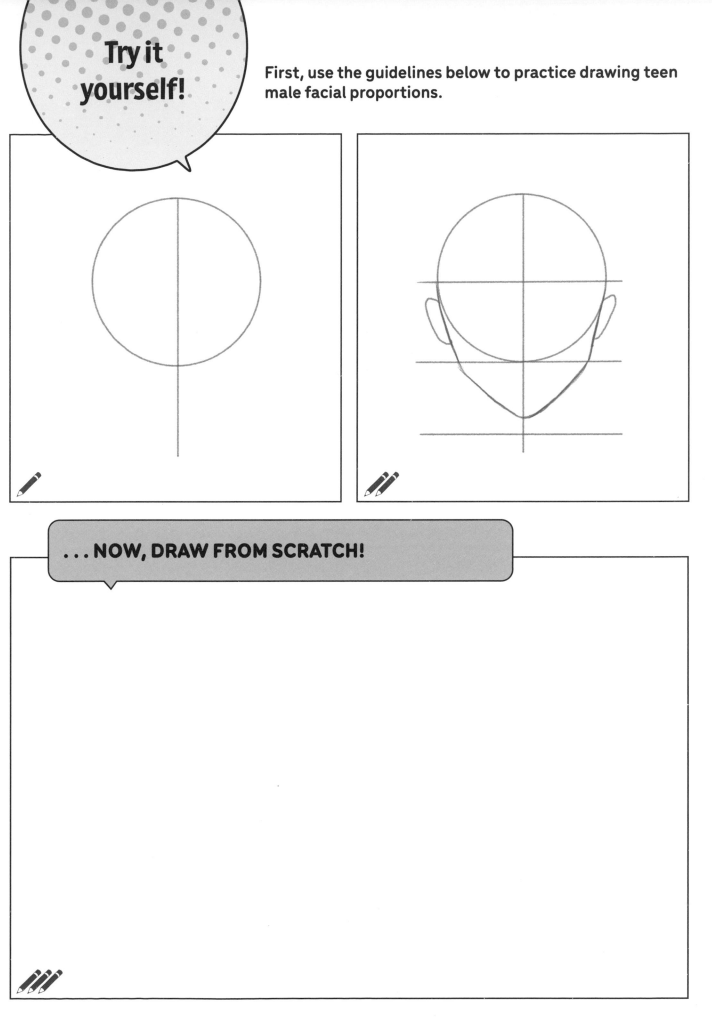

. . . NOW, DRAW FROM SCRATCH!

# Teen Male: Profile View

This tutorial shows you how to draw a teen boy seen from the side.

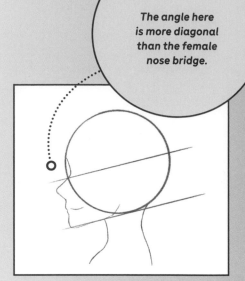

*The angle here is more diagonal than the female nose bridge.*

**1** Draw a circle with a line through the center, angled to where the eyes are looking. Draw a second line parallel to this at the circle base.

**2** Add the nose bridge, chin, and neck. The red guidelines will help you here.

**3** Join the nose bridge to the jaw.

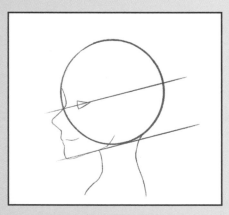

**4** Add the base triangle for the eye.

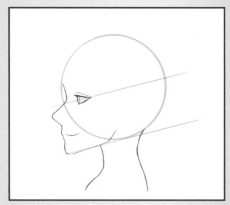

**5** Add the eye details.

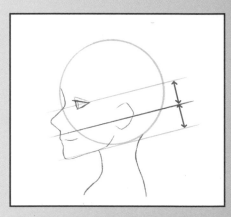

**6** Add a mid-section guideline to help draw the ear.

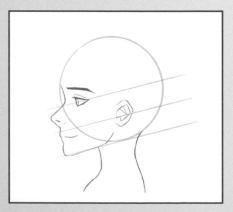

**7** Add the eye details, eyebrow, and nostril.

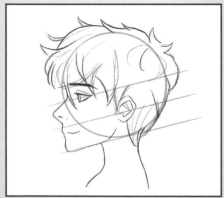

**8** Sketch the hair.

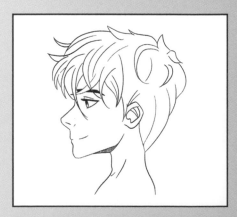

**9** Draw the finer hair details. Add shading and an eyelid.

# Practice!

First, draw on top of these guidelines to understand the male profile view.

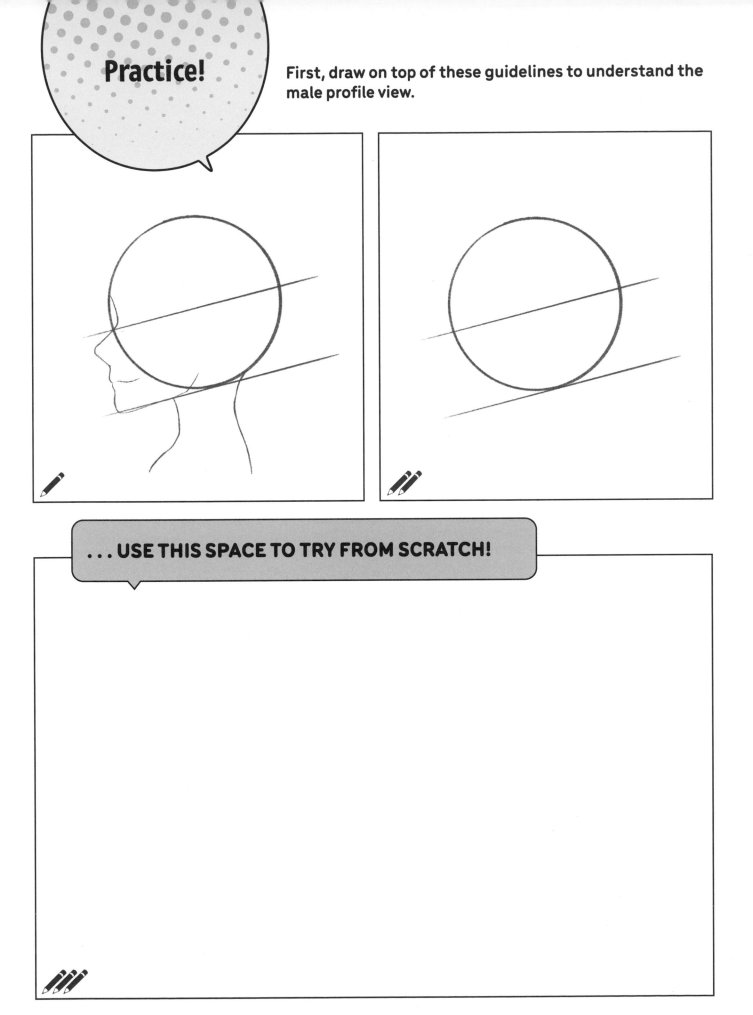

. . . USE THIS SPACE TO TRY FROM SCRATCH!

# Teen Male: Three-Quarter View

In this tutorial, you'll learn how to draw a teen boy from the three-quarter angle.

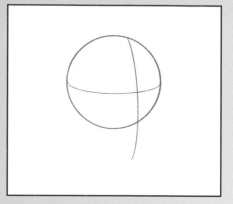

**1** Draw a sphere with a horizontal bisecting line. Draw a curved vertical line going through where the profile of the face will lie.

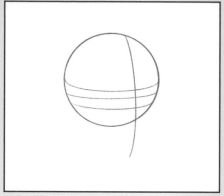

**2** Map the eye size with two horizontal lines beneath the first.

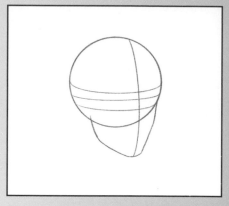

**3** Draw the face shape using the guidelines.

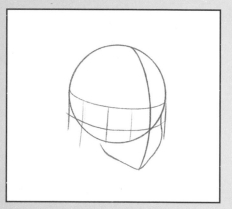

**4** Using the distance between the right side of the face and the profile line as a guide, split the rest of the head.

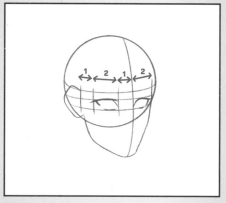

**5** In the third and fifth sections, draw the eye outlines. Draw the ear.

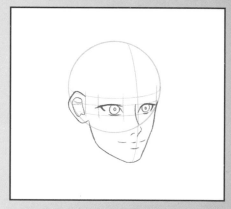

**6** Add pupils, irises, ear details, nose, and mouth.

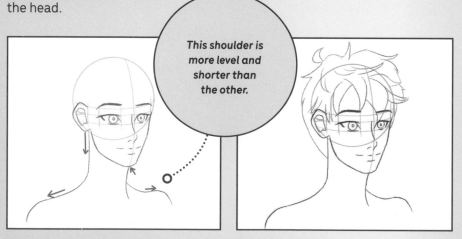

*This shoulder is more level and shorter than the other.*

**7** Add the eyebrows, neck, and shoulders.

**8** Sketch the hair.

**9** Draw the line art, adding hair details, shading, eyelashes, and eyelids.

**Try it below!**

First, use the guidelines below to understand the male profile view.

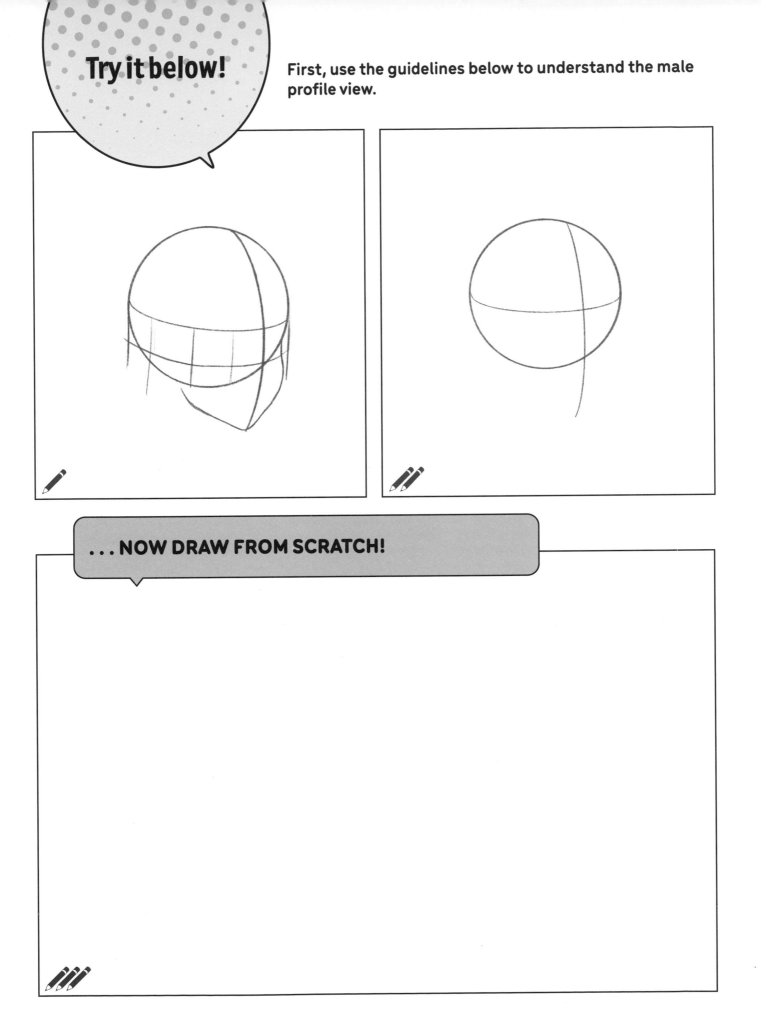

. . . NOW DRAW FROM SCRATCH!

# Adult Female: Front View

Follow this tutorial to learn how to draw an adult woman's head from the front.

Use soft angles to create an adult female face.

**1** Start with the same guidelines as the teen front views.

**2** Add the equally spaced facial shape guidelines.

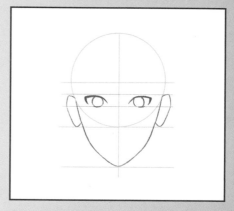

**3** Connect the guidelines, starting farther down the circle than in the teen view, in one flowing sweep to the bottom line.

Adult eyes tend to be smaller than teen and child eyes.

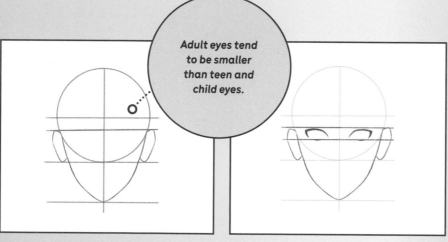

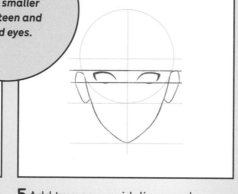

**4** Start drawing the ears from where the circle meets the outline of the lower face.

**5** Add two new guidelines and outline the eyes.

**6** Add the irises.

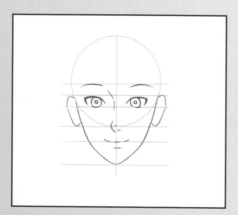

**7** Add the eyebrows, nose, and mouth.

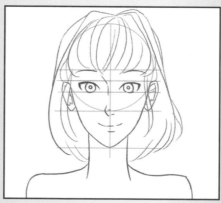

**8** Sketch the hair.

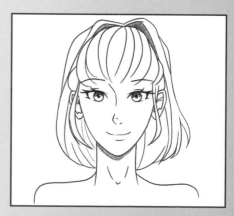

**9** Draw the line art, adding hair details, shading, eyelashes, and eyelids.

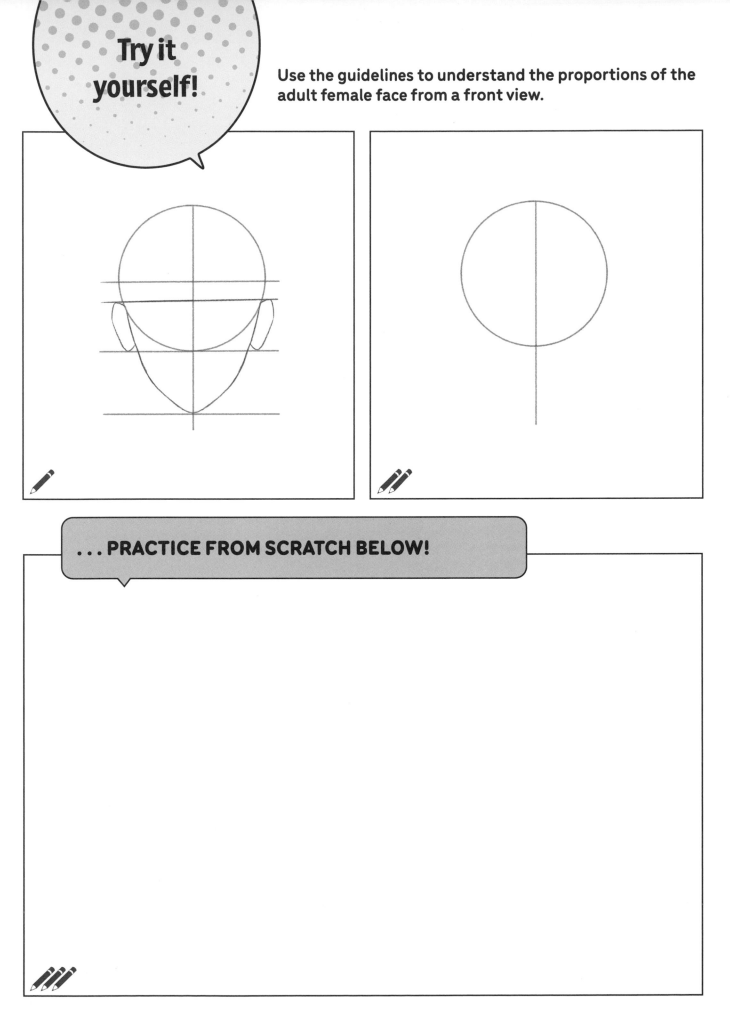

**Try it yourself!**

Use the guidelines to understand the proportions of the adult female face from a front view.

. . . PRACTICE FROM SCRATCH BELOW!

# Adult Male: Front View

Learn how to draw an adult man seen from the front in this tutorial.

*Adult faces tend to be longer and more pronounced with sharper angles.*

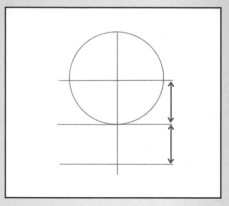

**1** Start with the same guidelines as the teen front views.

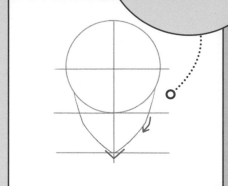

**2** Add the equally spaced facial shape guidelines.

**3** Connect the guidelines, starting farther down the circle and reaching the bottom line.

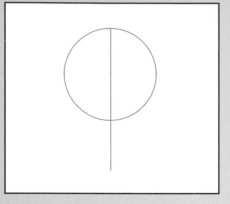

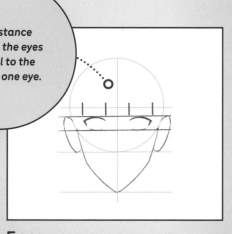

*The distance between the eyes is equal to the width of one eye.*

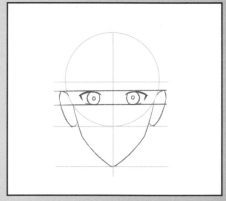

**4** Draw the ears, flowing out from where the circle meets the outline of the lower face.

**5** Add two new guidelines, the first across the tops of the ears and the second through the red highlighted points in the image. Outline the eyes.

**6** Add the irises and pupils.

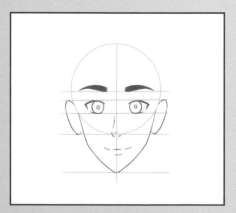

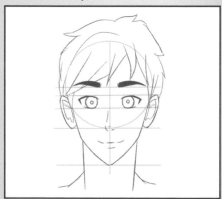

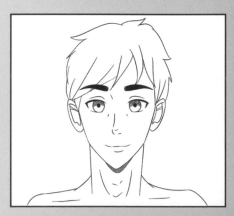

**7** Add the eyebrows, nose, and mouth.

**8** Sketch the hair.

**9** Add hair details, shading, and eyelids.

# Practice!

First, use these guidelines to practice drawing the adult male front view.

. . . NOW, TRY FROM SCRATCH!

# Child Female: Front View

The facial features of your characters will differ depending on their age. The girl in this tutorial has larger eyes and a shorter head than the teen or adult.

**1** Start with these guidelines. (Second step of previous tutorials.)

**2** Halve the lower section.

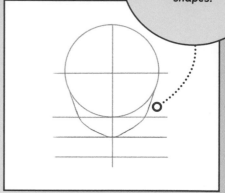

*Children have shorter and rounder face shapes.*

**3** Draw the lines of the lower face.

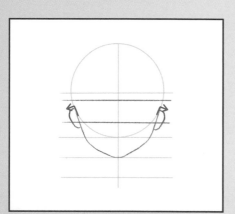

**4** Draw the ears coming out of the circle and face intersection. Add large eye guidelines.

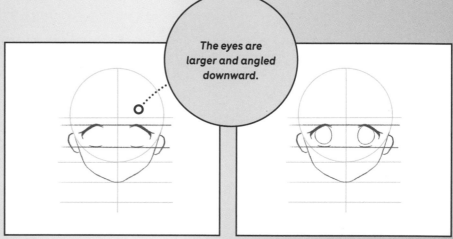

*The eyes are larger and angled downward.*

**5** Outline the eyes.

**6** Add large irises.

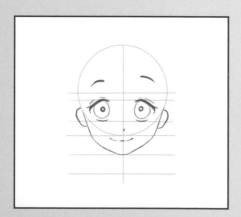

**7** Add the nose, eyebrows, and pupils.

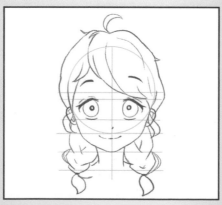

**8** Sketch the hair. Little tufts of loose hair will emphasize the youthful look.

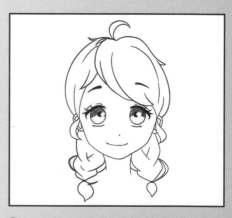

**9** Draw the line art, adding hair details, shading, eyelashes, and eyelids.

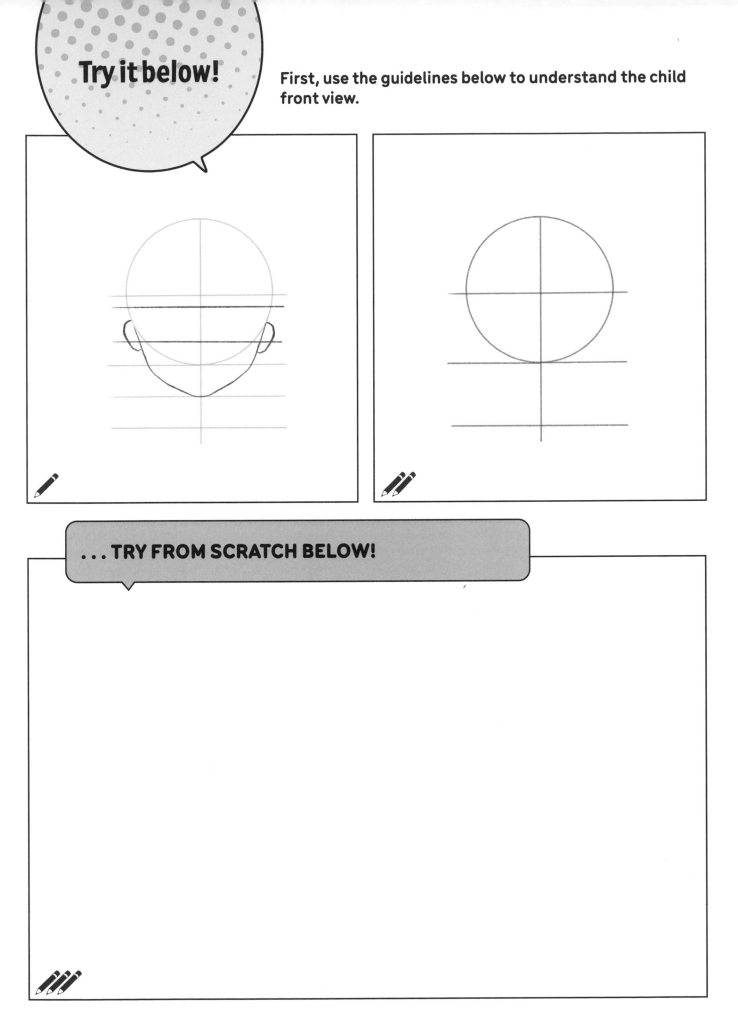

**Try it below!**

First, use the guidelines below to understand the child front view.

**. . . TRY FROM SCRATCH BELOW!**

# Child Male: Multiple Views

The facial shapes of all children are very similar, so you can follow the same proportions here as in the previous tutorial. Let's draw a short-haired boy, then do some quick alternate views.

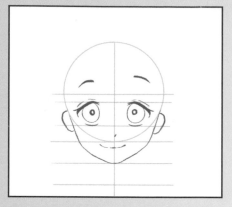

**1** Follow the child female tutorial up to this point.

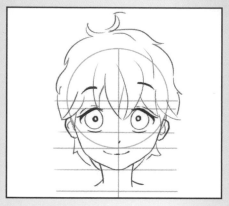

**2** Sketch the hair.

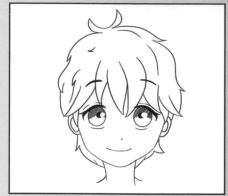

**3** Quick and easy!

**4** Start with the basic guidelines for profiles.

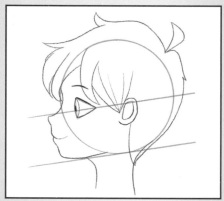

**5** Add the facial features using the guidelines.

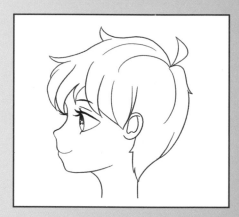

**6** Finally, line art.

*It helps to visualize the head as a 3D sphere here.*

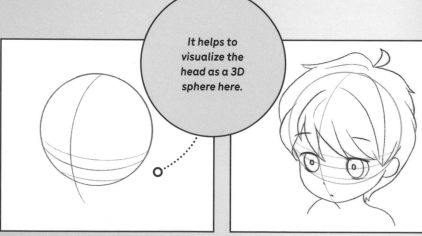

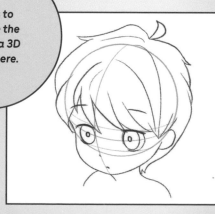

**7** Draw the basic guidelines, then add curved horizontal lines where the top, center, and bottom of the eyes will be.

**8** Sketch the features.

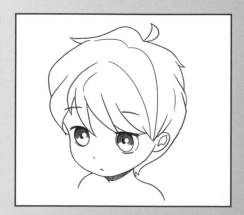

**9** Line art! This angle is tricky, so don't be afraid if it's not quite right first time. Practice makes perfect!

Draw each of these alternate views using the guides to start, then try from scratch.

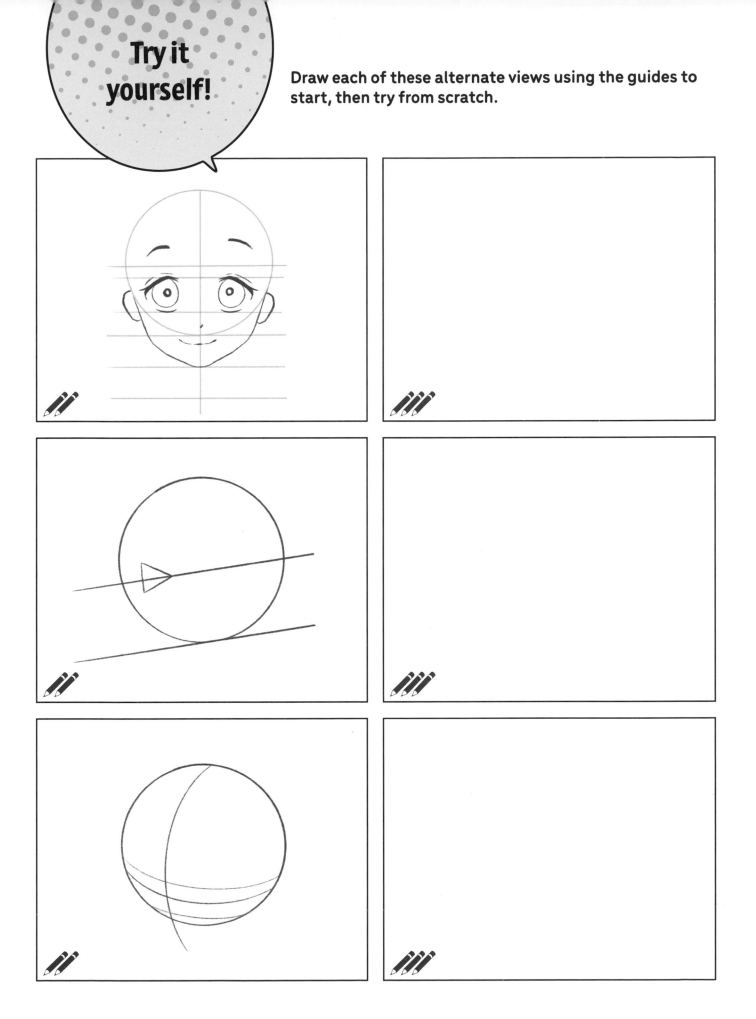

# Senior Female: Multiple Views

Using the adult facial proportions as a base, this tutorial will help you understand how to change connecting lines and features to age up your characters.

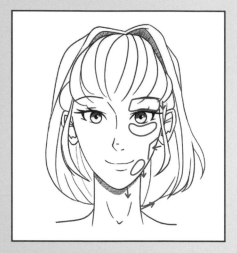

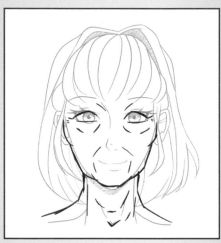

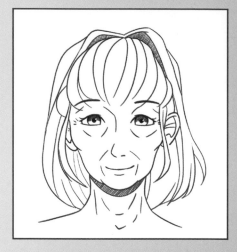

**1** Where there are key facial muscles, the skin is looser.

**2** See this overlay of the changes on the original adult drawing.

**3** The result is a more senior character.

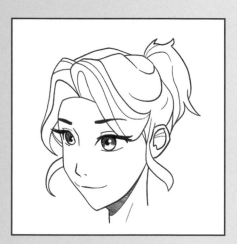

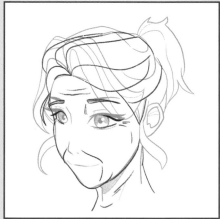

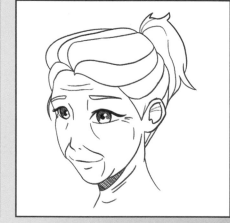

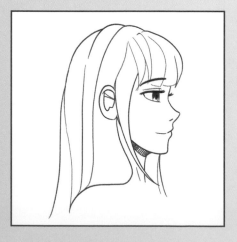

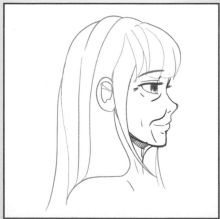

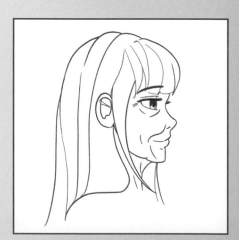

# Practice!

**Age up these characters as shown in the tutorial.**

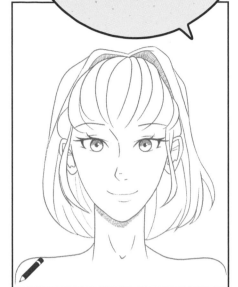

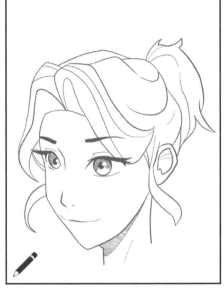

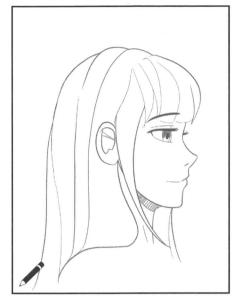

## . . . DRAW YOUR OWN CHARACTER AND AGE THEM UP!

# Senior Male: Multiple Views

The practice of aging up the male face is similar to aging up the female face. Use this page to further understand the theory as it applies to a senior male character.

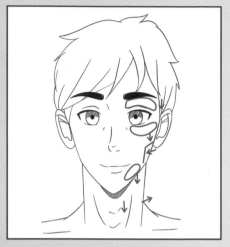

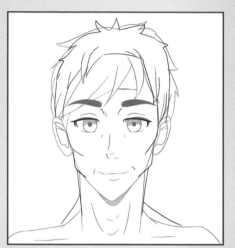

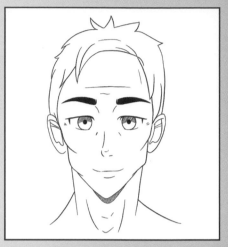

**1** Where there are key facial muscles, the skin is looser.

**2** See this overlay of the changes on the original adult drawing.

**3** The result is a more senior character.

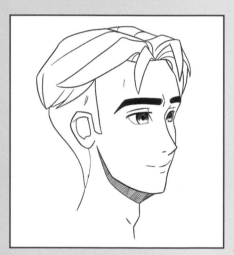

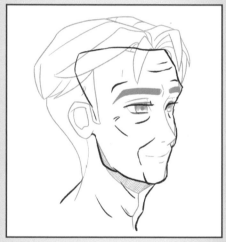

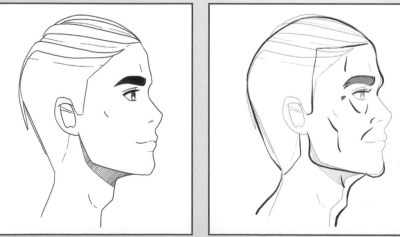

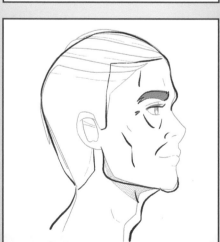

## Try it below!

Age up these characters as shown in the tutorial.

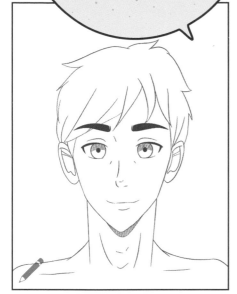

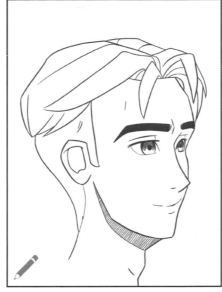

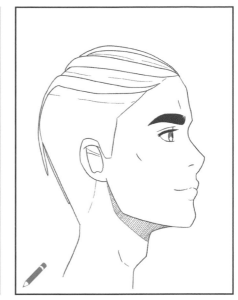

## . . . DRAW YOUR OWN SENIOR CHARACTER!

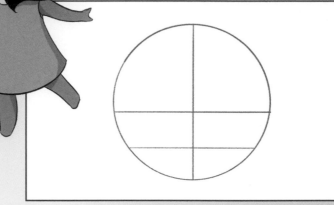

*Chibis have very small necks, or sometimes no neck at all depending on how short the character is.*

*If you decide to add a body, use the height of your chibi to guide you. If the chibi is two chibi heads tall, do not add a neck. If the chibi is three to four heads tall, add a small neck.*

# Chibi: Front View

Chibis are small and cute with exaggerated features. Their heads and eyes are large, with round childlike proportions. Focus on perfecting the face shape and eyes first, and the rest will follow!

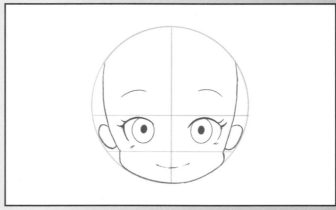

**1** Sketch a circle with a horizontal line just below the central point. Draw a second horizontal line in the lower half of the circle, again placing it slightly lower than the central point.

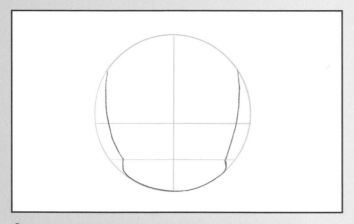

**2** Draw the face shape, keeping the cheeks in the lowest section. The sides of the head are similar in shape to the sides of an oval.

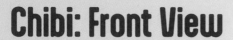

**3** Add the facial features using the guidelines. The eye widths are large, equal to almost one-fifth of the guideline circle diameter!

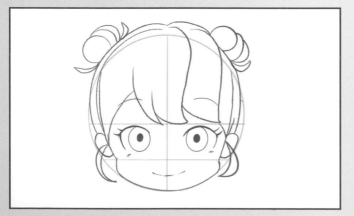

**4** Sketch your character's hair over the top half of the face.

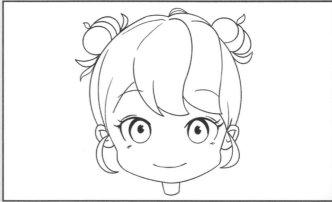

**5** Finish the piece with your line art. Emphasize those big eyes!

# Try it yourself!

Practice chibi facial proportions below, remembering to keep a distance between the eyes, which is roughly equal to the size of one eye.

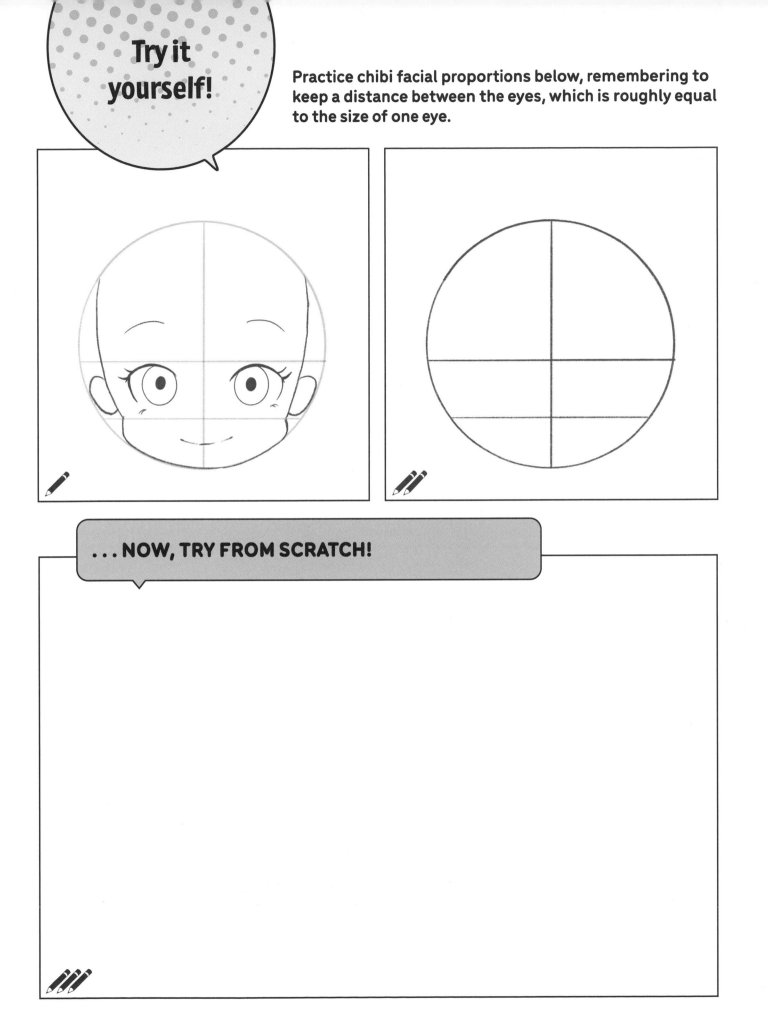

. . . NOW, TRY FROM SCRATCH!

# Chibi: Three-Quarter View

You will probably draw three-quarter views most often, so let's try a three-quarter view of a chibi.

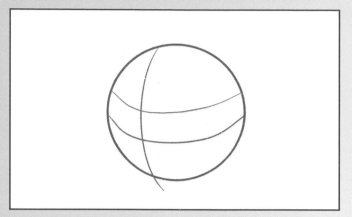

**1** Sketch a sphere with a horizontal curved line just below the circle center. Draw a second horizontal curved line, higher than the first, where you would like the top of the eyes to be. Add a vertical line as shown.

**2** Draw the face shape, following the lines of the circle on the right-hand side of the face, then deviating on the left to add the angle and the round cheeks.

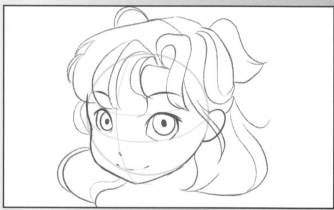

**3** Add the facial features using the guidelines. The eye widths are large, equal to almost one-fifth of the guideline circle diameter!

**4** Sketch the hair. This character is at an angle, so remember to extend the hair out past her ear.

*Manga styles and characters vary, so experiment once you understand the fundamentals. You can also position the facial features more toward the lower half of the face if you like!*

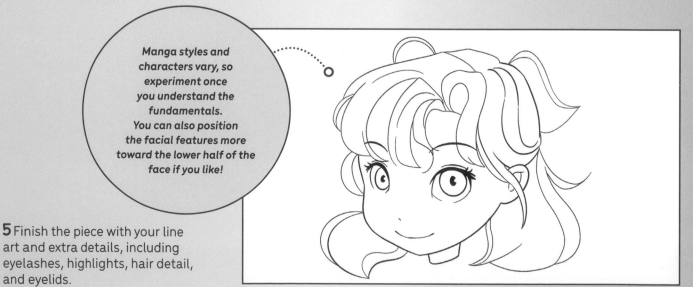

**5** Finish the piece with your line art and extra details, including eyelashes, highlights, hair detail, and eyelids.

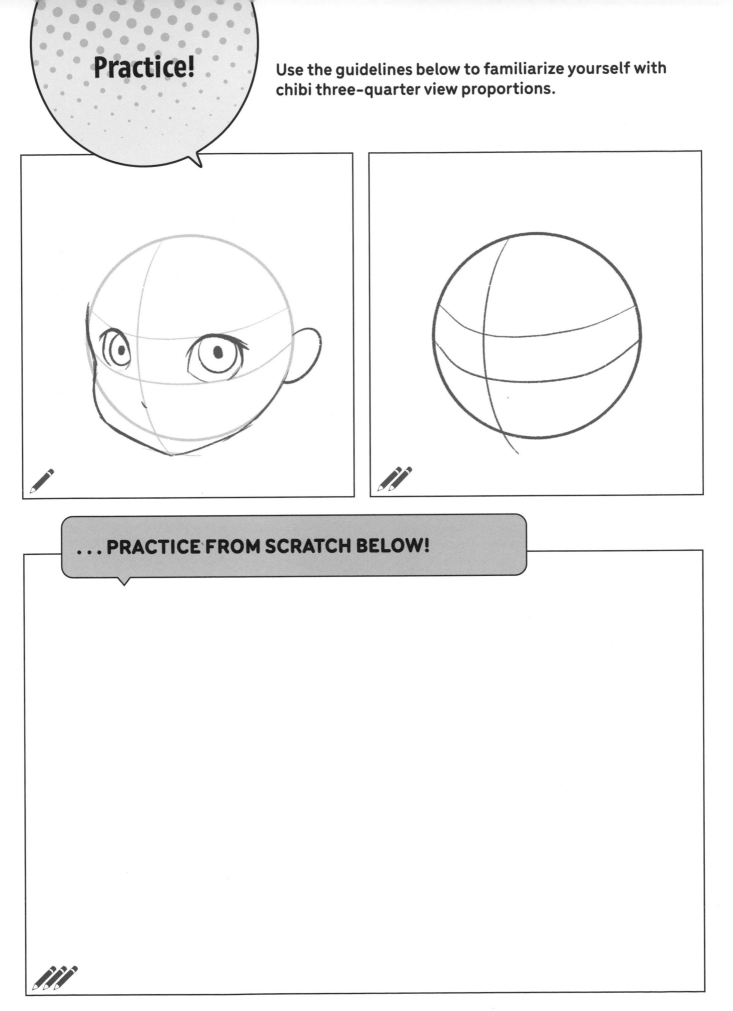

# Practice!

Use the guidelines below to familiarize yourself with chibi three-quarter view proportions.

. . . PRACTICE FROM SCRATCH BELOW!

**CHAPTER 2**

# Facial Features

This section teaches you how to draw basic facial features and demonstrates some easy ways to mix and match.

First, we'll look at the manga eye, one of the most memorable features of the manga art style. Then we'll cover the nose, mouth, facial markings, and accessories.

This chapter is the foundation for learning how to create different facial expressions, so make full use of the practice pages!

# Basics of the Manga Eye

Manga eyes tell the reader a lot, from the theme of the manga or the era it was written in, to what a character is feeling. Understanding basic eye anatomy will help you draw your own manga eyes.

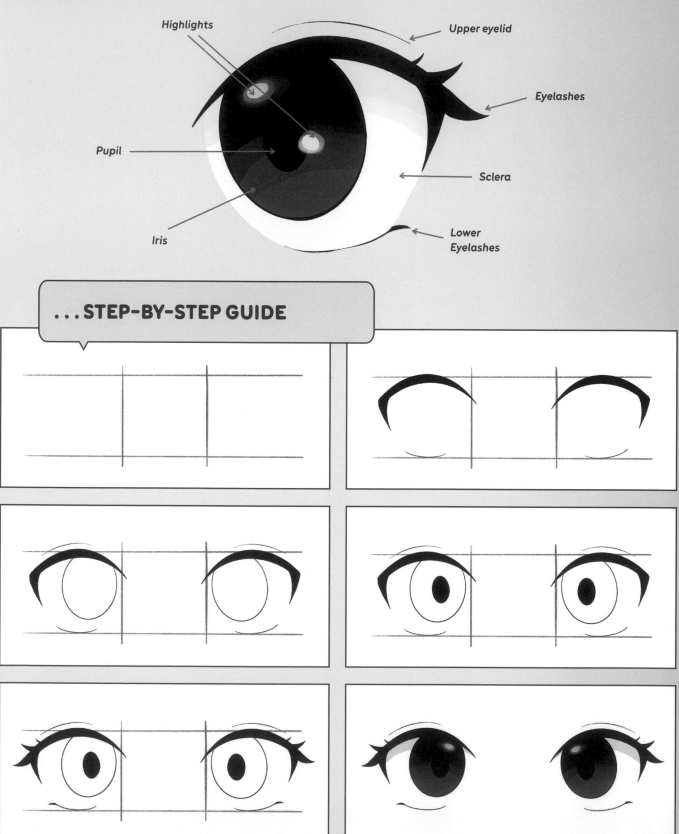

Highlights

Upper eyelid

Eyelashes

Pupil

Sclera

Iris

Lower Eyelashes

## ...STEP-BY-STEP GUIDE

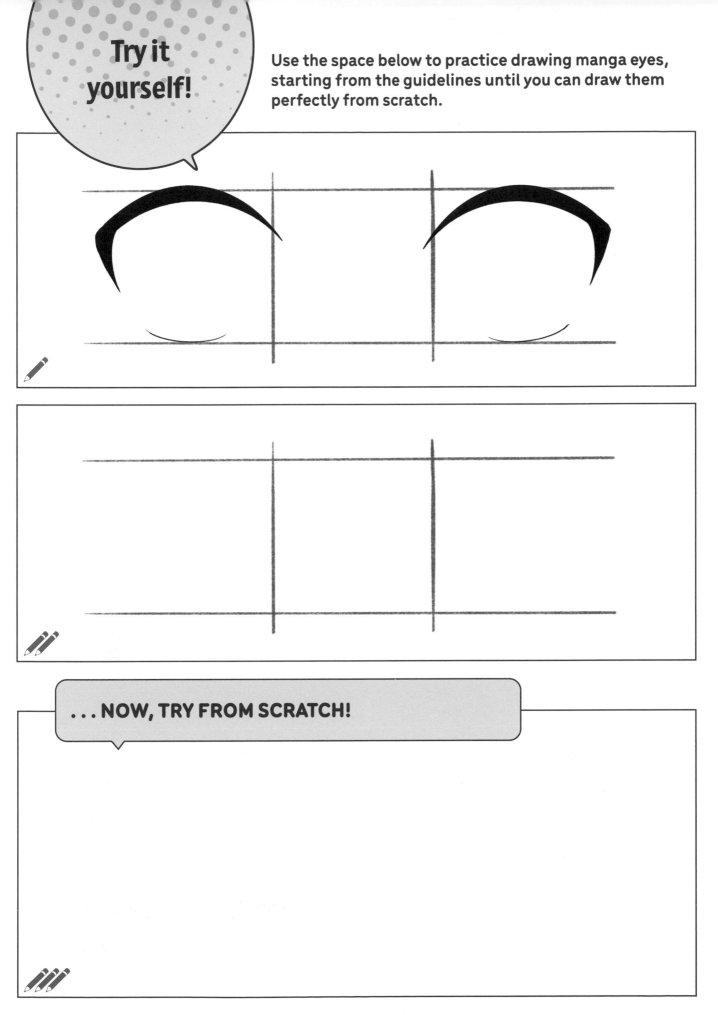

**Try it yourself!**

Use the space below to practice drawing manga eyes, starting from the guidelines until you can draw them perfectly from scratch.

**. . . NOW, TRY FROM SCRATCH!**

# Manga Eye Sizes

The size of the eye can sometimes indicate a particular manga type or era. Very large eyes were often seen in the '90s, for example. Large eyes are more cartoonish while smaller eyes look more realistic.

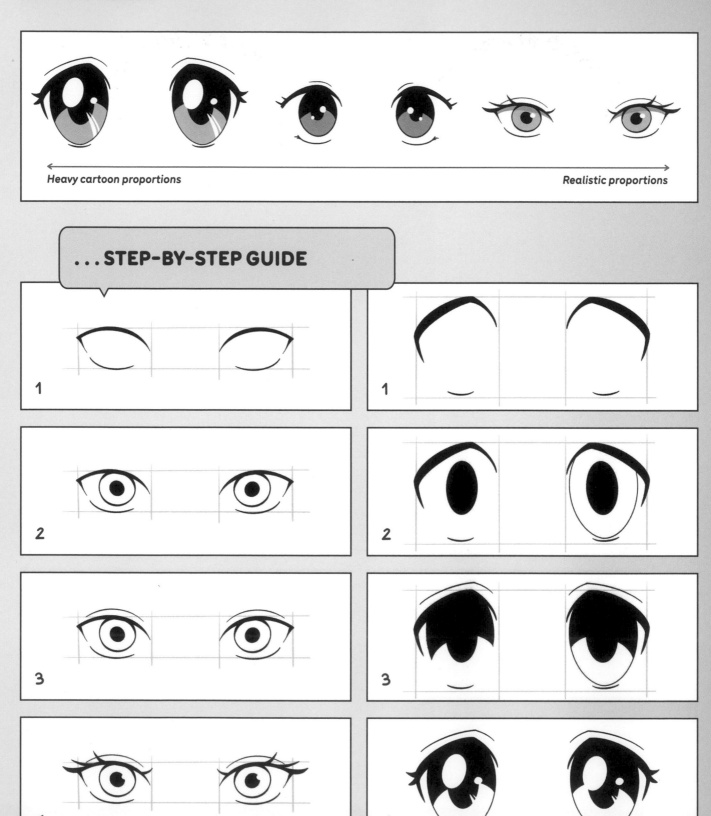

*Heavy cartoon proportions*

*Realistic proportions*

**...STEP-BY-STEP GUIDE**

1

1

2

2

3

3

4

4

# Practice!

Following the step-by-step guide on the previous page, practice drawing smaller and larger manga eyes in the space below.

...TRY FROM SCRATCH BELOW!

# Manga Eye Examples

The feelings or personality of a character, as well as your art style, can determine what shaped eyes you give your characters. Eyes can range from rectangular or square to circular or elliptical, as shown in the box below.

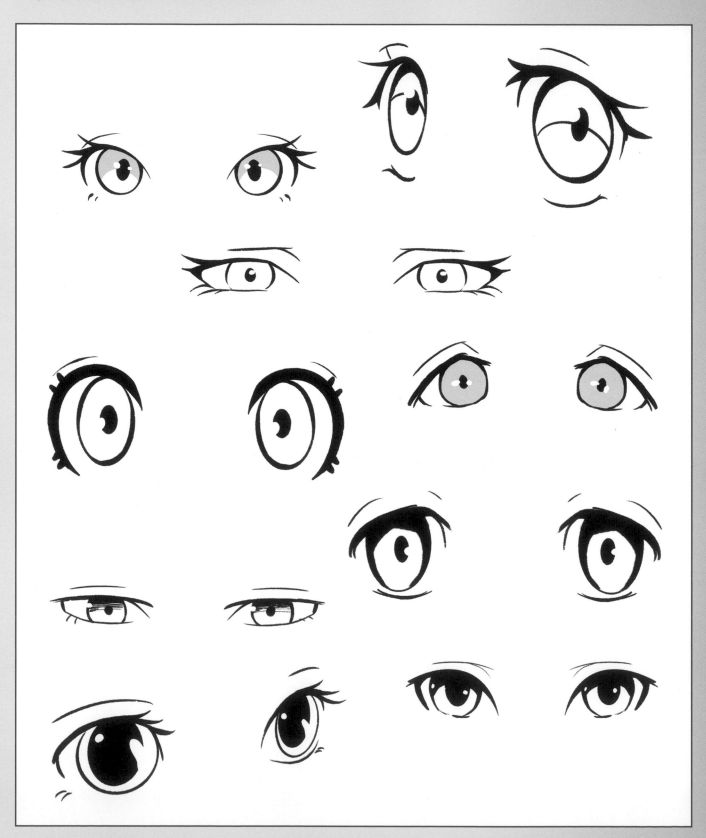

Try out some of the example eyes on the characters below, or even make up your own eyes! Focus on placing and proportioning the eyes correctly. Work in pencil so you can erase it and try again if you don't get it right the first time.

*Once you have given your characters eyes, feel free to practice sketching hair and other customizations.*

# Manga Noses

Manga noses are drawn using small, simple lines with some variations adding nostrils, nose bridges, and shading. Following the tutorials below, practice drawing these nose shapes.

**FRONT VIEW**

**THREE-QUARTER VIEW**

**PROFILE VIEW**

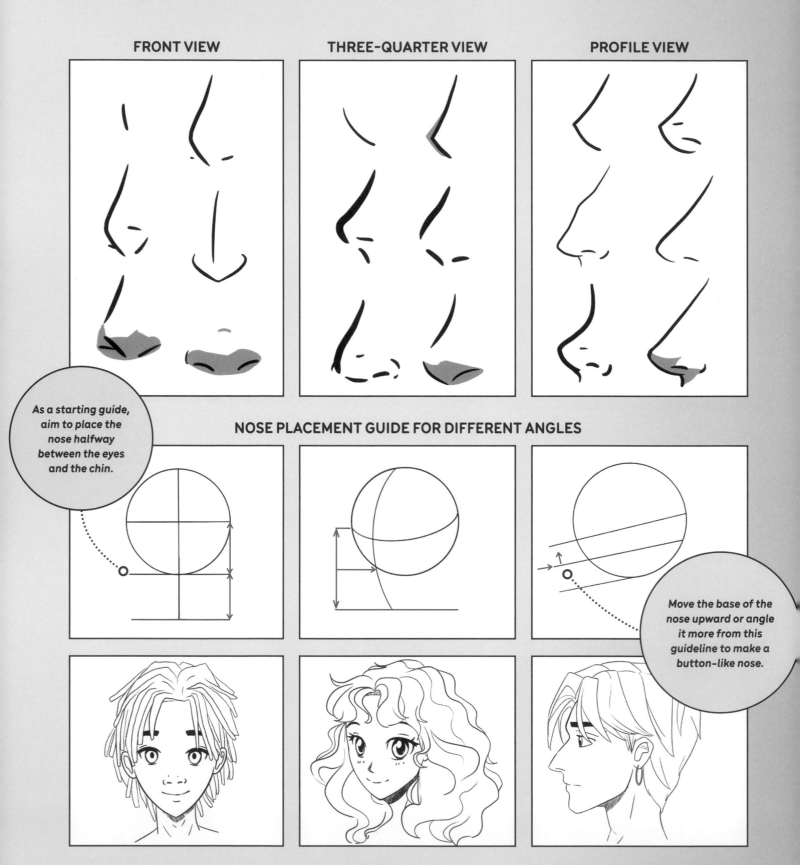

*As a starting guide, aim to place the nose halfway between the eyes and the chin.*

**NOSE PLACEMENT GUIDE FOR DIFFERENT ANGLES**

*Move the base of the nose upward or angle it more from this guideline to make a button-like nose.*

**Try it yourself!**

Redraw the front view, three-quarter view, and profile view noses in the space below.

*Add noses to these characters.*

# Manga Mouths

The mouth is one of the easiest facial features to convey a character's emotions. Copy these example mouths to become more familiar with the shapes.

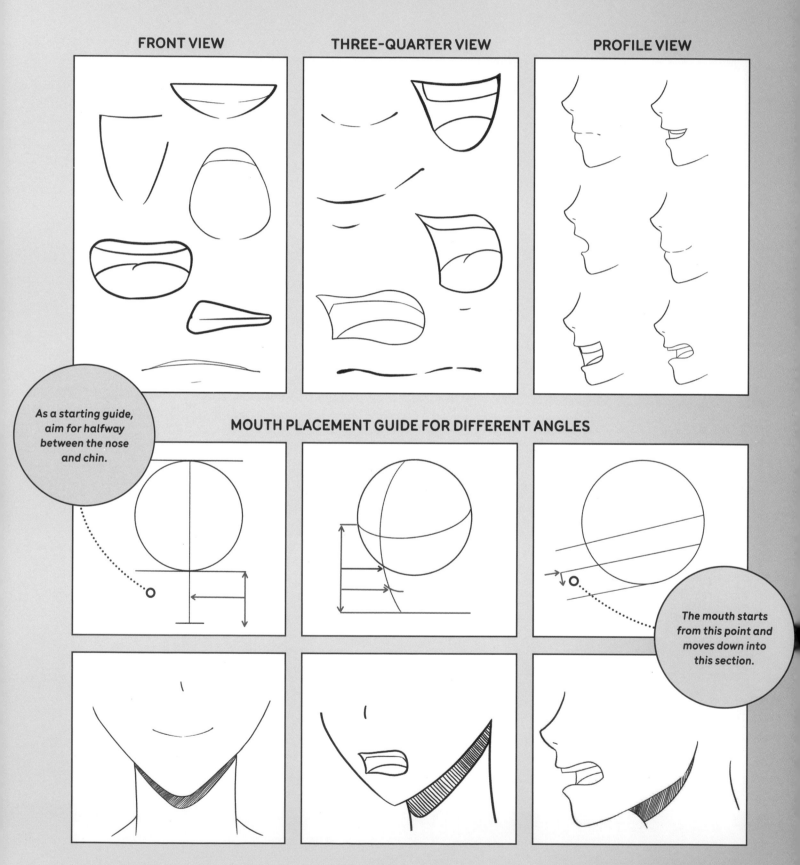

**FRONT VIEW**

**THREE-QUARTER VIEW**

**PROFILE VIEW**

*As a starting guide, aim for halfway between the nose and chin.*

**MOUTH PLACEMENT GUIDE FOR DIFFERENT ANGLES**

*The mouth starts from this point and moves down into this section.*

# Practice!

**Redraw the example mouths in the space below.**

Add mouths to these characters.

# Facial Marks

Scars, tattoos, birthmarks, and distinct makeup can define a character or shape your story's plot. Marks are usually permanent, helping readers distinguish between character identities. These markings can relate to the character's backstory or just look visually interesting.

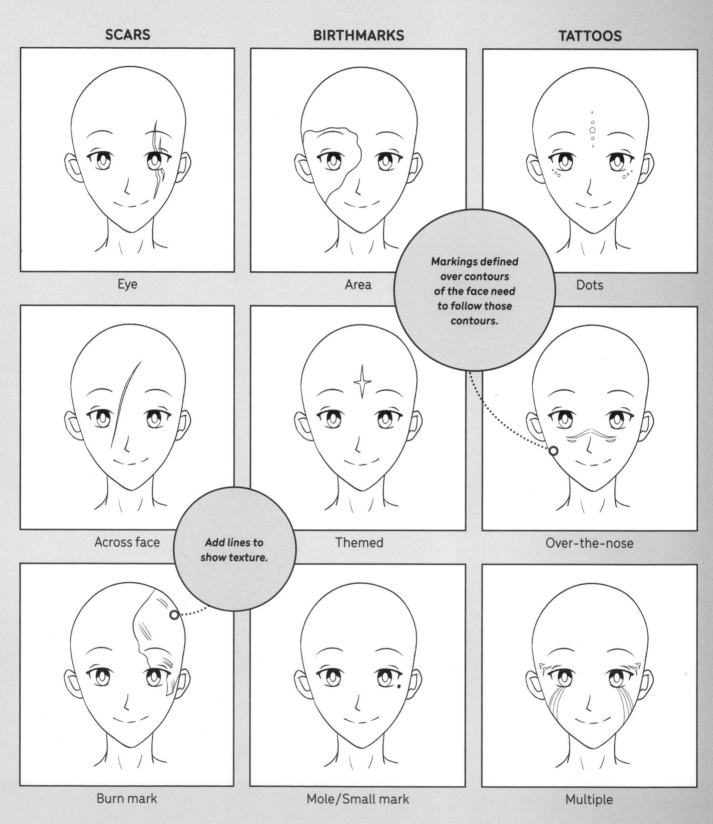

**SCARS**

Eye

Across face

Burn mark

**BIRTHMARKS**

Area

Themed

Mole/Small mark

**TATTOOS**

Dots

Over-the-nose

Multiple

*Markings defined over contours of the face need to follow those contours.*

*Add lines to show texture.*

**Try it below!**

Copy some of the example facial marks or make up your own on these character heads.

**...TRY FROM SCRATCH BELOW!**

# Facial Accessories

Facial accessories are a fun and easy way to alter a character's appearance.

## GLASSES PLACEMENT

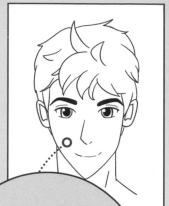 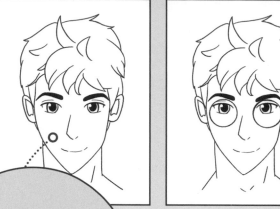  

*Generally, the bottom of the glasses rest on the tops of the cheeks, but you can place them higher or lower if you want the glasses to be smaller or bigger.*

## FACIAL HAIR

Facial hair grows out of the face in different directions around the contours of the face.

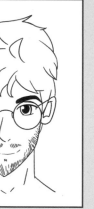 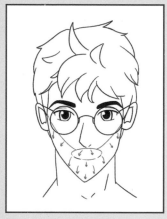 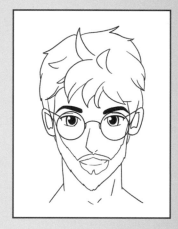

## FACE MASKS

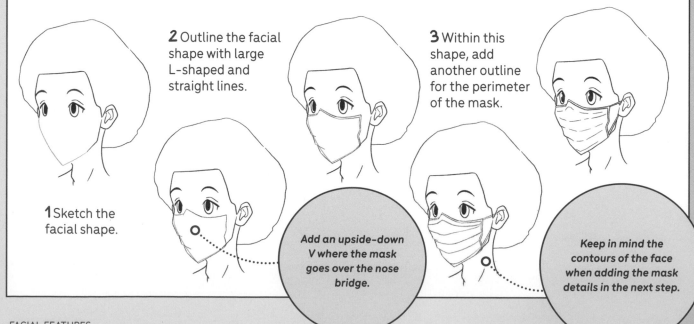

**1** Sketch the facial shape.

**2** Outline the facial shape with large L-shaped and straight lines.

**3** Within this shape, add another outline for the perimeter of the mask.

*Add an upside-down V where the mask goes over the nose bridge.*

*Keep in mind the contours of the face when adding the mask details in the next step.*

## Try it yourself!

Practice what you've learned in the tutorials on these characters, then go over it with line art.

...NOW, TRY FROM SCRATCH!

# Practice!

Use these pages to show your understanding of facial features. Face-shape guidelines have been provided so you can focus on the features.

CHAPTER 3

# Facial Expressions

It's time to learn how to draw a range of emotions and facial expressions!

Start with understanding the range of movement that your facial features can make. Then, explore their combinations to create a wide library of expressions. Follow the tutorials for happy, sad, daily, and dynamic expressions, creating some emotive characters.

# Basics of Facial Expressions

When you understand the key muscle groups in the face and how they can move, manipulating the features to show emotion becomes easy.

**THE BASIC FACIAL MUSCLE GROUPS***

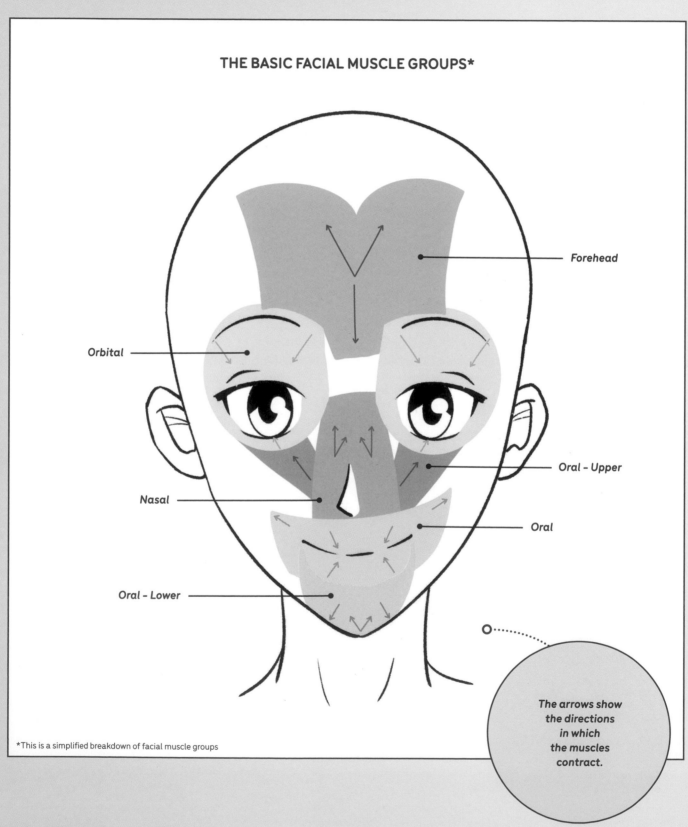

Forehead

Orbital

Oral – Upper

Nasal

Oral

Oral – Lower

*The arrows show the directions in which the muscles contract.*

*This is a simplified breakdown of facial muscle groups

# Basics of Facial Expressions

Look at the effects of each muscle group movement. Through the simplest of adjustments, the entire emotion of the character is dramatically changed.

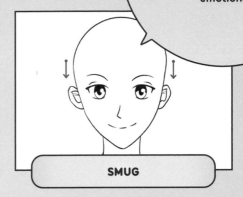

*When you create combinations of these foundation movements, you can show all types of emotions!*

## FOREHEAD

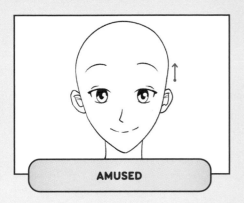

AMUSED

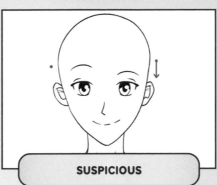

SUSPICIOUS

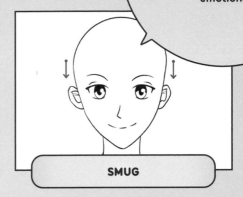

SMUG

## ORBITAL

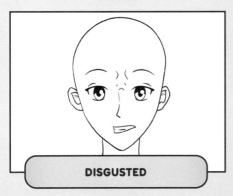

PLEASED

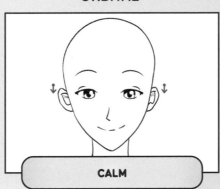

CALM

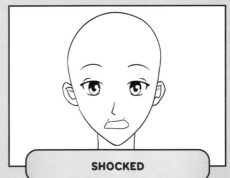

FOND

## NASAL

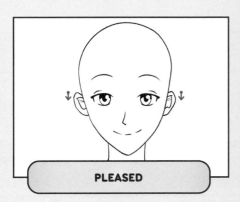

DISGUSTED

## ORAL - UPPER

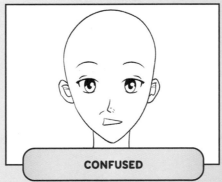

CONFUSED

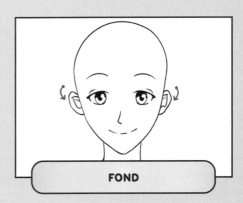

SHOCKED

## ORAL – LOWER

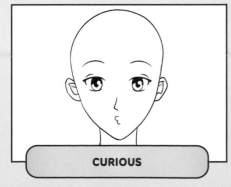

CURIOUS

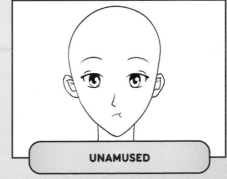

UNAMUSED

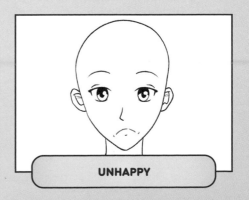

UNHAPPY

# Happy Expressions

Happy facial expressions tend to involve angling the outer corners of features upward and lifting the position of the top of the lip. Follow these tutorials to draw some happy characters.

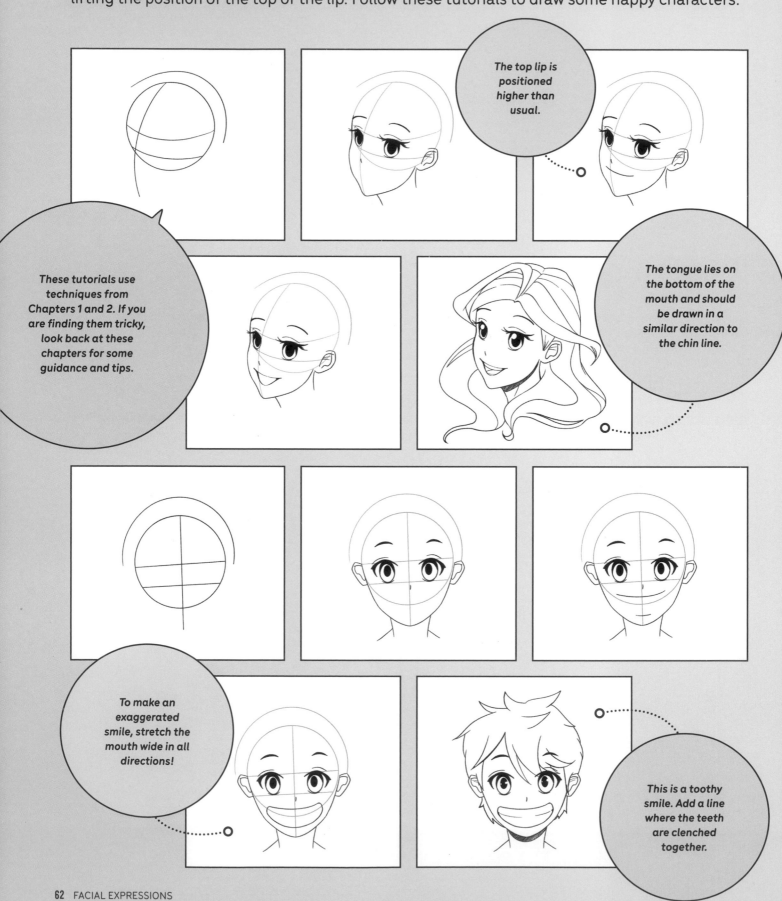

The top lip is positioned higher than usual.

*These tutorials use techniques from Chapters 1 and 2. If you are finding them tricky, look back at these chapters for some guidance and tips.*

*The tongue lies on the bottom of the mouth and should be drawn in a similar direction to the chin line.*

*To make an exaggerated smile, stretch the mouth wide in all directions!*

*This is a toothy smile. Add a line where the teeth are clenched together.*

**Try it yourself!**

Practice the tutorials on these character guidelines, then try drawing them from scratch.

# Happy Expressions

Strong feelings of joy and sudden laughter can tilt the head into different directions. Follow these tutorials to draw some joyful characters.

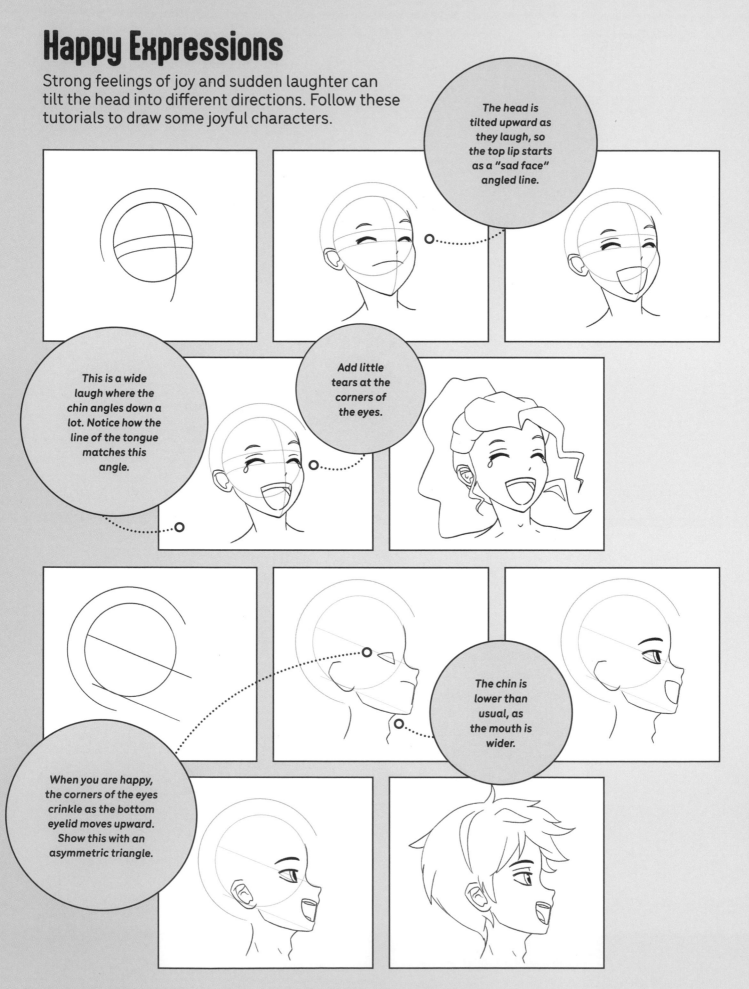

The head is tilted upward as they laugh, so the top lip starts as a "sad face" angled line.

This is a wide laugh where the chin angles down a lot. Notice how the line of the tongue matches this angle.

Add little tears at the corners of the eyes.

The chin is lower than usual, as the mouth is wider.

When you are happy, the corners of the eyes crinkle as the bottom eyelid moves upward. Show this with an asymmetric triangle.

**Practice!**

Follow the tutorials on these character guidelines, then try drawing them from scratch.

# Sad Expressions

Sadness is conveyed with heavy eyelids, crinkled-up eyes, and downward-angled features. Try out these tutorials to make some solemn-looking characters.

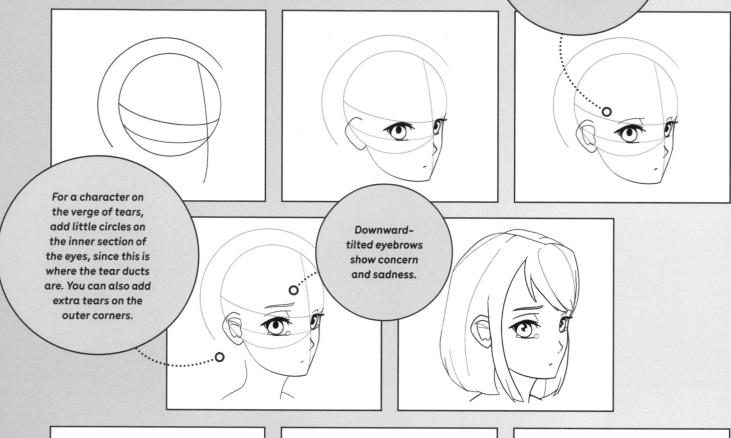

The eyelids are thicker here, suggesting tiredness or puffiness from crying.

For a character on the verge of tears, add little circles on the inner section of the eyes, since this is where the tear ducts are. You can also add extra tears on the outer corners.

Downward-tilted eyebrows show concern and sadness.

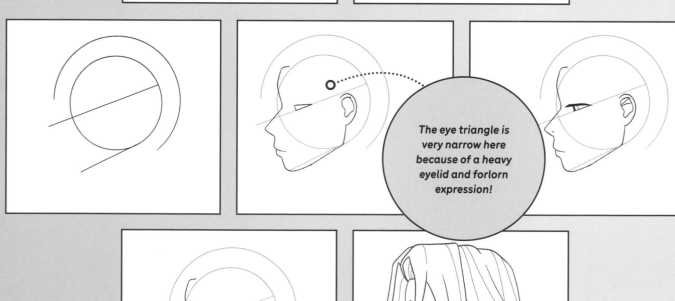

The eye triangle is very narrow here because of a heavy eyelid and forlorn expression!

**Try it below!**

Practice drawing sad expressions on these character guidelines, then try drawing them from scratch.

# Sad Expressions

If your character needs to cry, use these tutorials to draw tears spilling from their eyes.

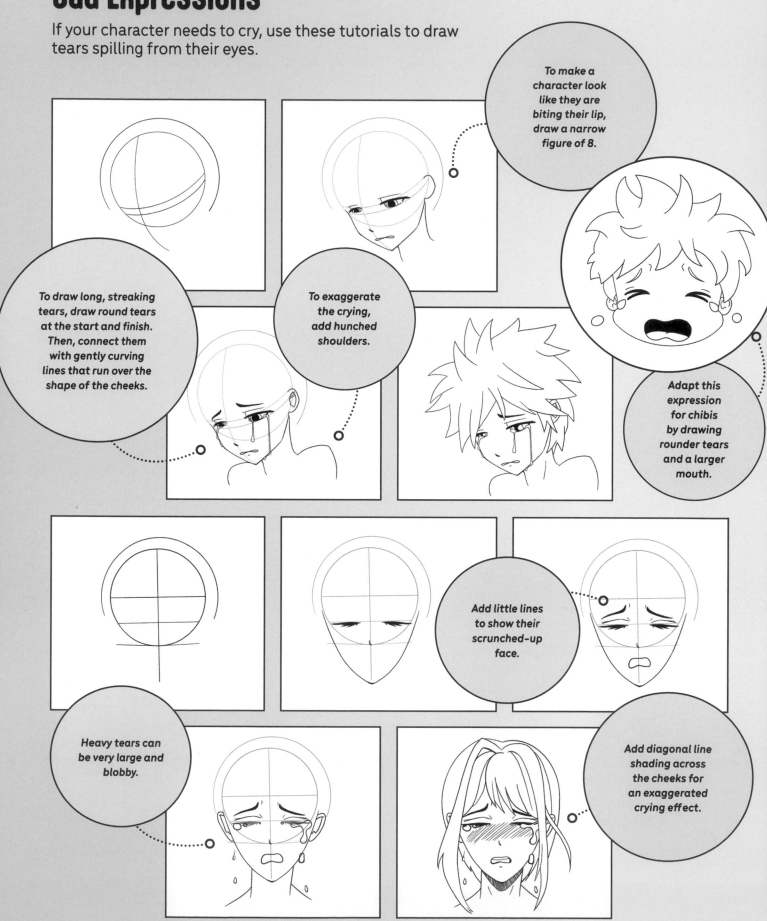

To make a character look like they are biting their lip, draw a narrow figure of 8.

To draw long, streaking tears, draw round tears at the start and finish. Then, connect them with gently curving lines that run over the shape of the cheeks.

To exaggerate the crying, add hunched shoulders.

Adapt this expression for chibis by drawing rounder tears and a larger mouth.

Add little lines to show their scrunched-up face.

Heavy tears can be very large and blobby.

Add diagonal line shading across the cheeks for an exaggerated crying effect.

**Try it yourself!**

Follow the tutorials on these character guidelines, then try drawing them from scratch.

# Daily Expressions

Food in manga always looks so good! Learn how to draw your characters enjoying a delicious meal with these two tutorials.

**CHEWING ON FOOD**

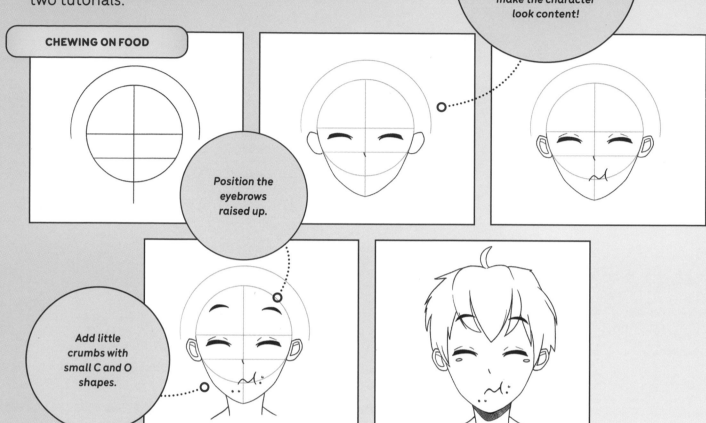

*Usually you're happy when eating. Give the closed eyes a "sad smile" curve to make the character look content!*

*Position the eyebrows raised up.*

*Add little crumbs with small C and O shapes.*

**ANTICIPATORY/ABOUT TO TAKE A BITE!**

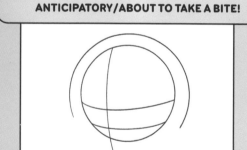

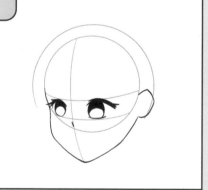

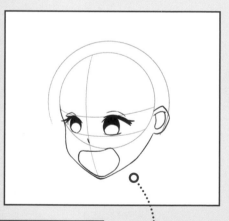

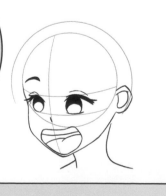

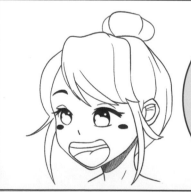

*Lots of large highlights can make the character look dazzled by what sits in front of them.*

*This character is wide-eyed with excitement looking at a delicious meal, about to take a bite.*

# Practice!

Follow the tutorials for daily expressions on the guidelines below, then try drawing them from scratch.

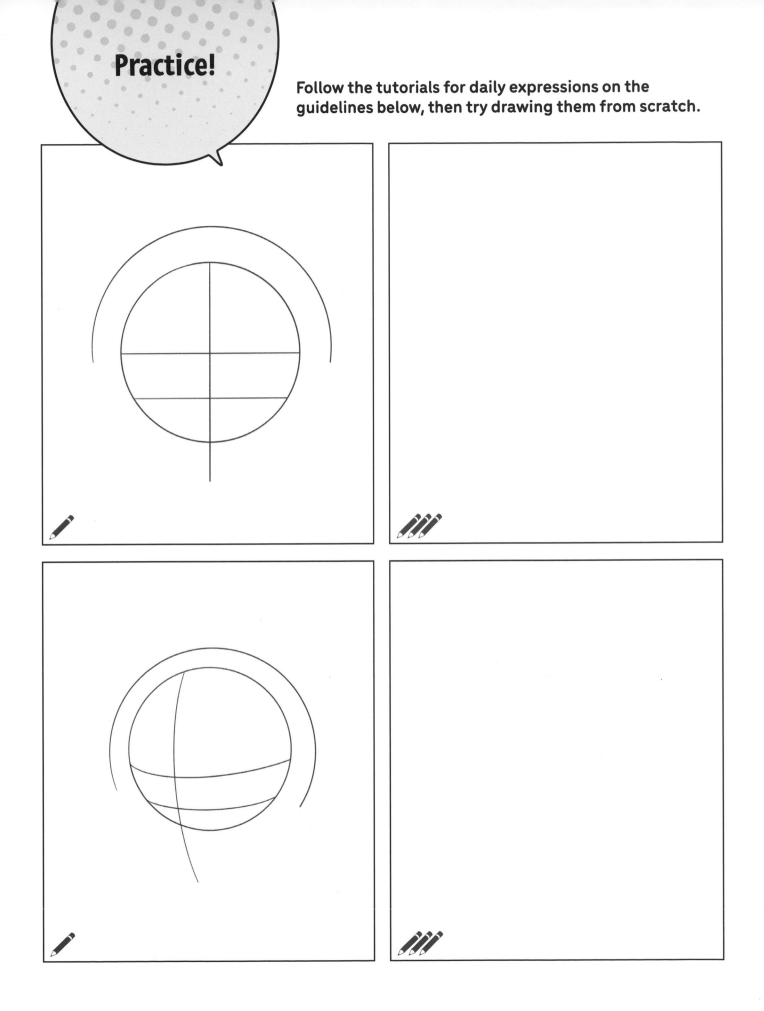

# Daily Expressions

Try out some embarrassed and confused expressions. Eyebrow movements combined with head tilts help to convey these emotions.

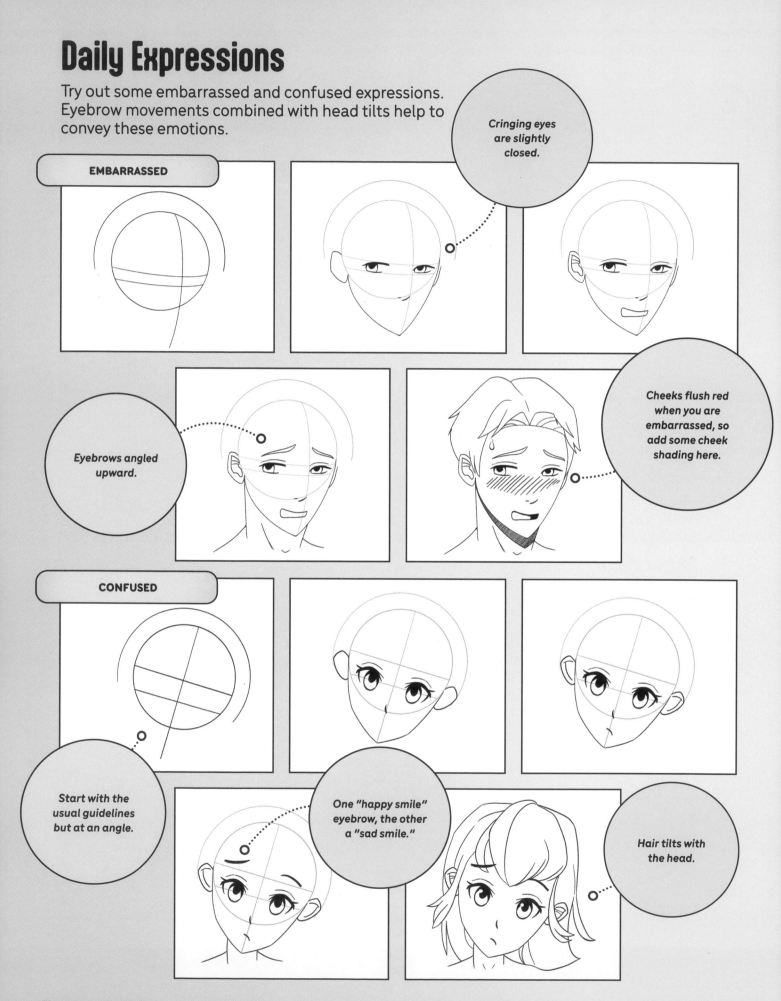

**EMBARRASSED**

*Cringing eyes are slightly closed.*

*Eyebrows angled upward.*

*Cheeks flush red when you are embarrassed, so add some cheek shading here.*

**CONFUSED**

*Start with the usual guidelines but at an angle.*

*One "happy smile" eyebrow, the other a "sad smile."*

*Hair tilts with the head.*

**Try it below!**

Follow the tutorials on these character guidelines and then try drawing them from scratch.

# Daily Expressions

Emotions like smugness or self-confidence can be shown with a simple smile and slightly closed eyelids. Make your character confident with these tutorials.

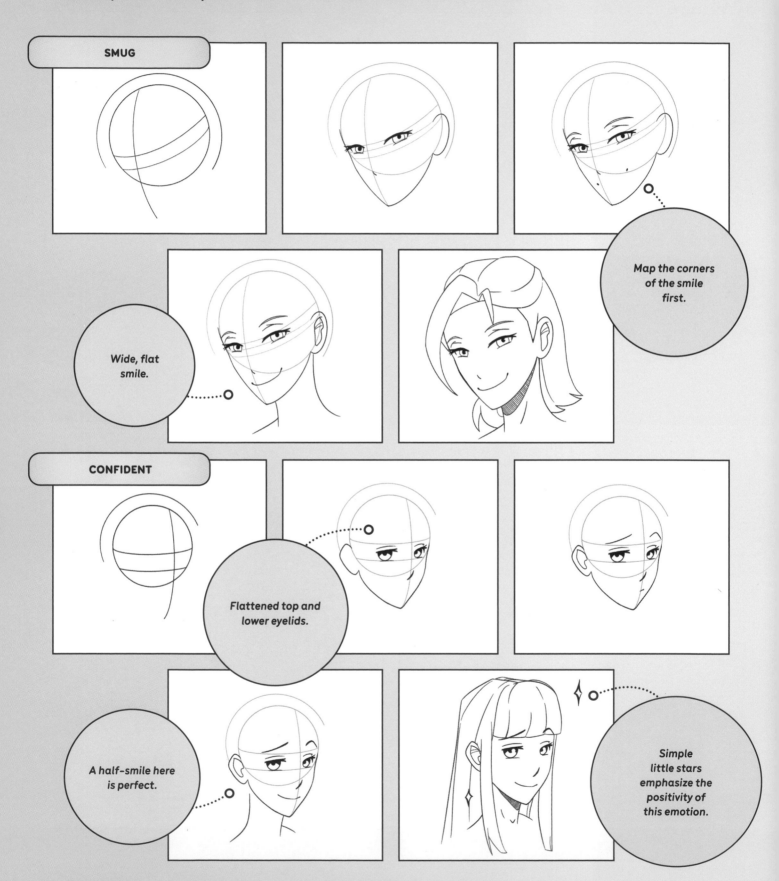

**SMUG**

*Map the corners of the smile first.*

*Wide, flat smile.*

**CONFIDENT**

*Flattened top and lower eyelids.*

*A half-smile here is perfect.*

*Simple little stars emphasize the positivity of this emotion.*

# Try it yourself!

Follow the tutorials on the guidelines below, then try drawing them from scratch.

# Daily Expressions

Smitten emotions are cute and very satisfying to draw. Follow this tutorial to create flirty and pleased characters.

**FLIRTY**

*A little wink is an easy way to make your character fun.*

*Floating hearts suggest a flirtier wink rather than a cheeky one.*

**PLEASED**

*Closed eyes can show satisfaction.*

*Raised eyebrows.*

*A simple curve for the smile.*

*A small amount of blush to show a wash of joy passing over the character.*

# Practice!

Follow the tutorials on these character guidelines, then try drawing them from scratch.

# Daily Expressions

Simplified half-moon eyes are a fun way to show boredom. They can also be made silly if combined with a little pout. Follow these tutorials for a bored and silly character.

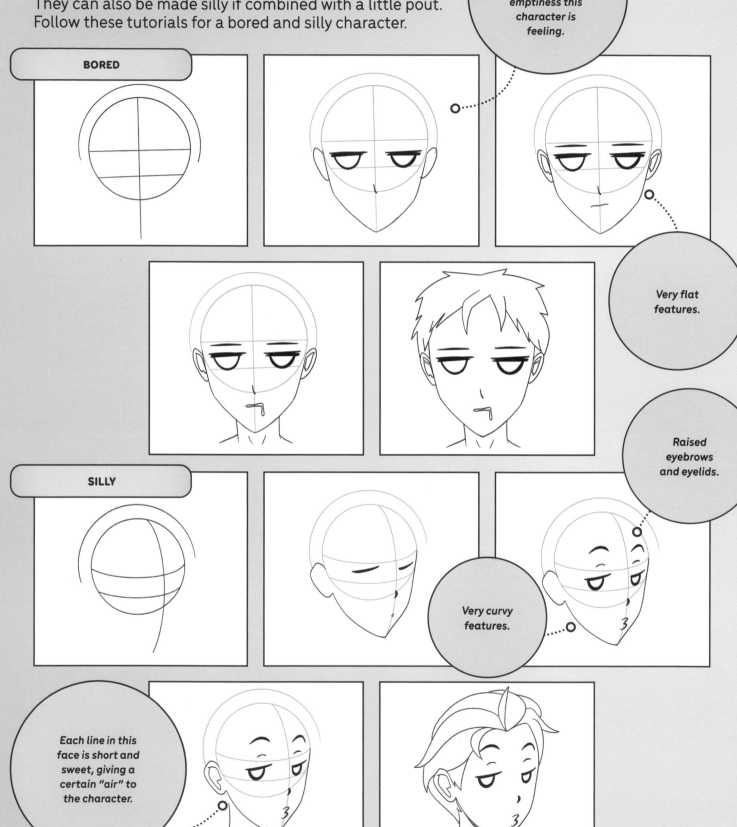

**BORED**

Empty eyes reflect the emptiness this character is feeling.

Very flat features.

Raised eyebrows and eyelids.

**SILLY**

Very curvy features.

Each line in this face is short and sweet, giving a certain "air" to the character.

**Try it below!**

Follow the tutorials on these character guidelines and then try drawing them from scratch.

# Dramatic Expressions

If your character is angry, angle the eyebrows downward, furrow the brow, and even add some little triangles to emphasize their outrage!

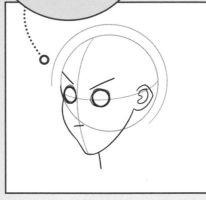

Roughly loop circles around the original circle.

**SHOCKED ANGER**

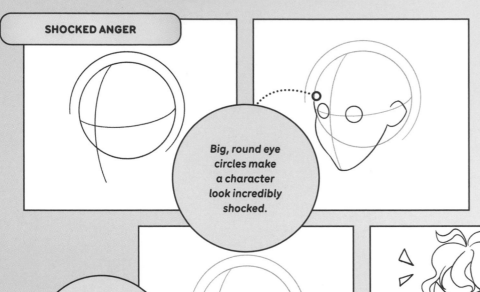

Big, round eye circles make a character look incredibly shocked.

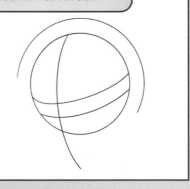

Draw the mouth down in a pear shape.

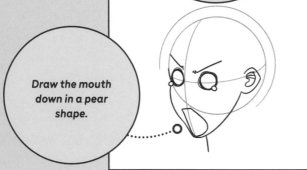

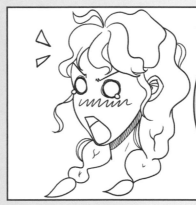

When drawing dramatic reactions, feel free to get creative with the features. You can even add extra icons around the character, such as hearts, stars, or triangles.

**FRUSTRATED ANGER**

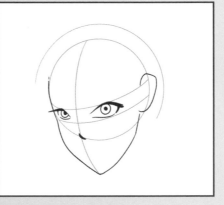

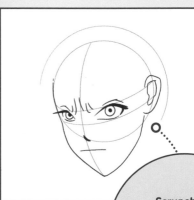

Scrunched-up brow with multiple L-shaped lines.

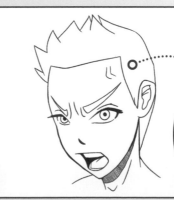

Add a popped vein with these two triangular lines.

Practice drawing dramatic expressions on these character guidelines, then draw them from scratch.

# Dramatic Expressions

Try out these emotions of delight and awe, which can be easily conveyed through changing the shape of the eyes.

*Draw two large hearts where you would normally place eyes.*

**IN LOVE**

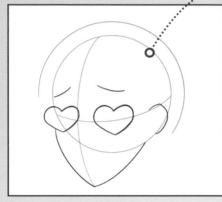

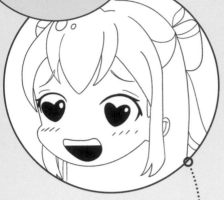

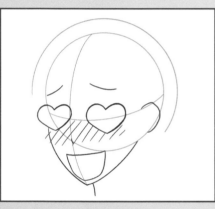

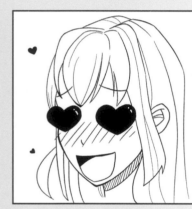

*In a round chibi face, these heart eyes become cuter and softer.*

**STARSTRUCK**

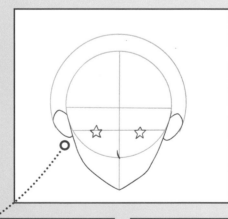

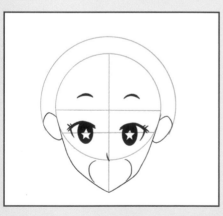

*Two little stars where the pupils would be.*

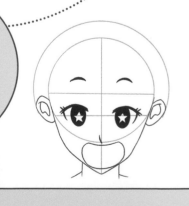

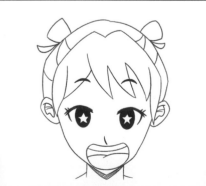

# Practice!

**Follow the tutorials on these character guidelines, then try drawing them from scratch.**

# Dramatic Expressions

Follow these tutorials to create some unwell-looking characters who are suffering from boredom or illness.

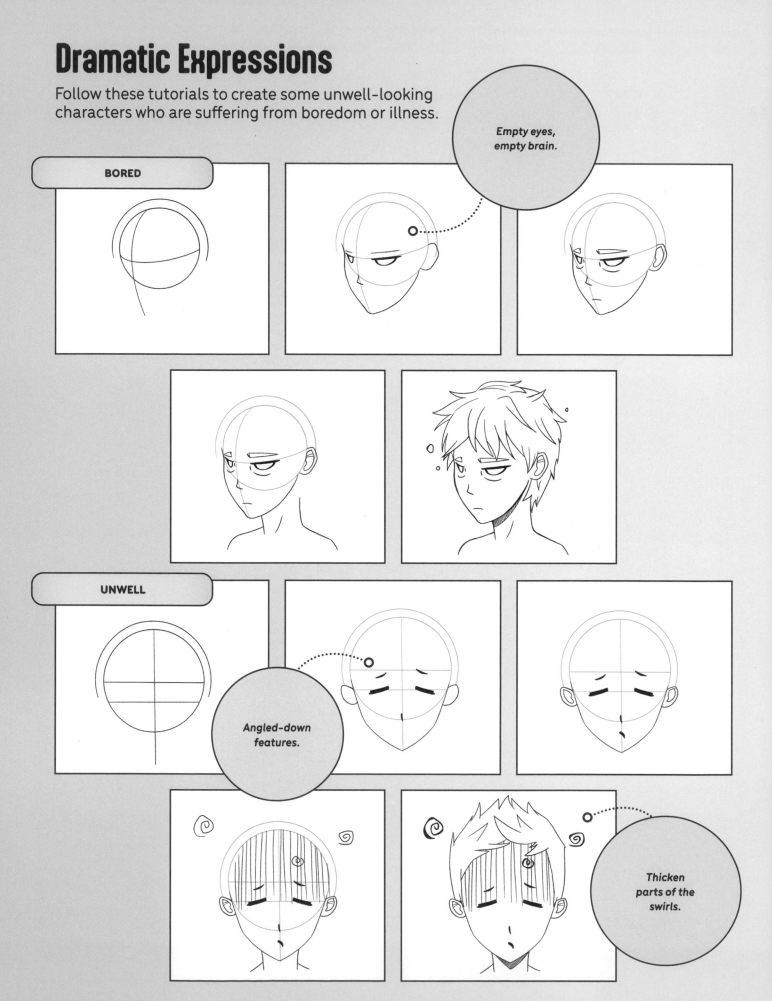

**BORED**

Empty eyes, empty brain.

**UNWELL**

Angled-down features.

Thicken parts of the swirls.

## Try it below!

Practice these expressions on the character guidelines below, then try drawing them from scratch.

# Dramatic Expressions

If your character is uncomfortable, use a cringing or awkward expression. The character can look relatively normal, or you can change the feature shapes and add excessive details to make an awkward-looking character.

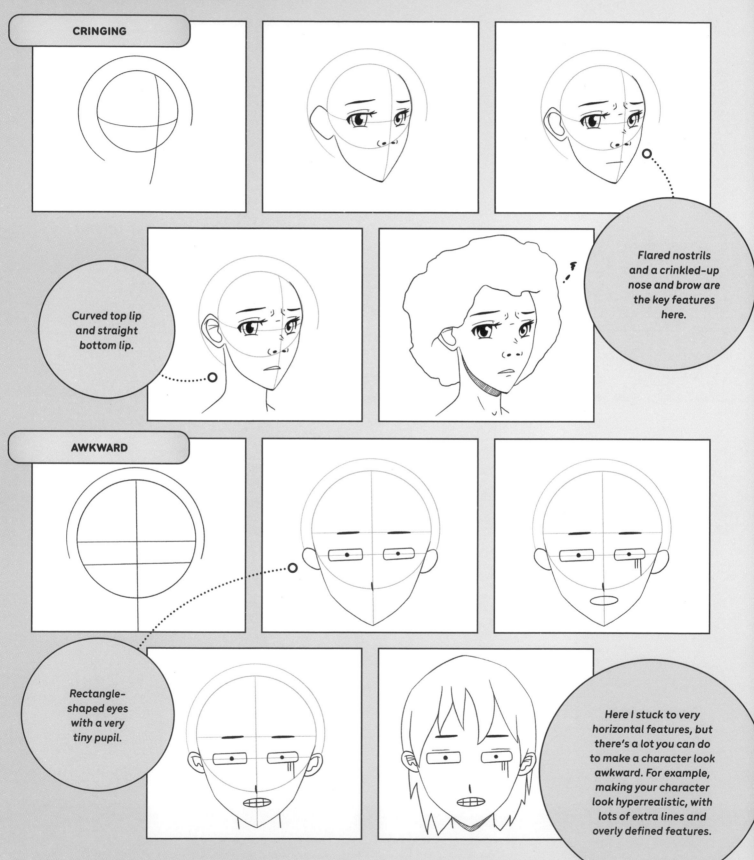

**CRINGING**

Flared nostrils and a crinkled-up nose and brow are the key features here.

Curved top lip and straight bottom lip.

**AWKWARD**

Rectangle-shaped eyes with a very tiny pupil.

Here I stuck to very horizontal features, but there's a lot you can do to make a character look awkward. For example, making your character look hyperrealistic, with lots of extra lines and overly defined features.

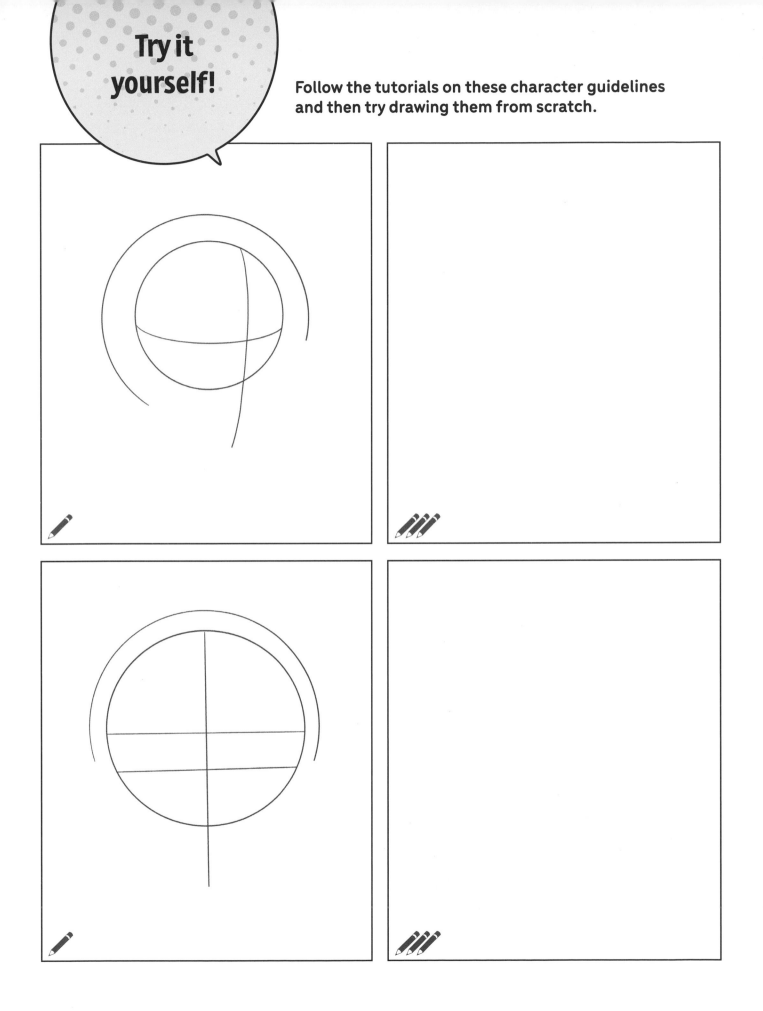

## Try it yourself!

**Follow the tutorials on these character guidelines and then try drawing them from scratch.**

# Dramatic Expressions

Evil and scared expressions are created using opposing linework—the scared expression uses "sad smile" shaped lines, while the evil face has "happy smile" shaped lines.

**Add a small teardrop outline on one eye.**

**SCARED**

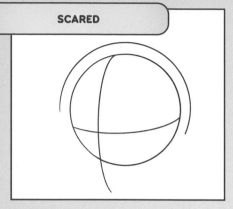

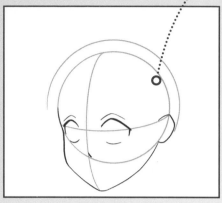

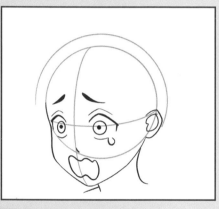

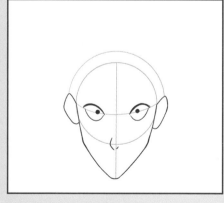

**Outline the character with disjointed wobbly lines to make it look like they are shaking.**

**EVIL**

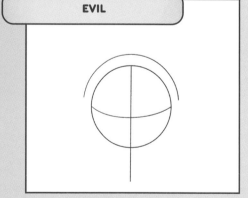

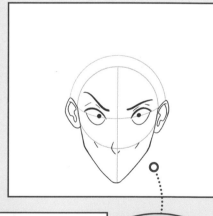

*When the eyebrows are pushed down this far, add small V shapes above the brow.*

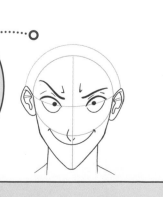

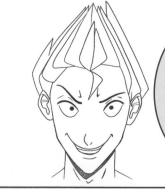

*Tilting the head down makes him look more evil. As a result, the perspective will make the top of the lip appear very close to the nose.*

# Practice!

Practice drawing evil and scared expressions in the space below.

# Practice!

Draw characters with a variety of expressions and emotions across these two pages. Have fun, and if you need some inspiration, flip back to the tutorials!

**. . . TRY IT BELOW!**

## Try it yourself!

Use these practice pages to create animated chibi characters showing expressions featured in this chapter. Chibis can be far more cartoonish and exaggerated with their expressions, so go wild!

## . . . PRACTICE MAKES PERFECT!

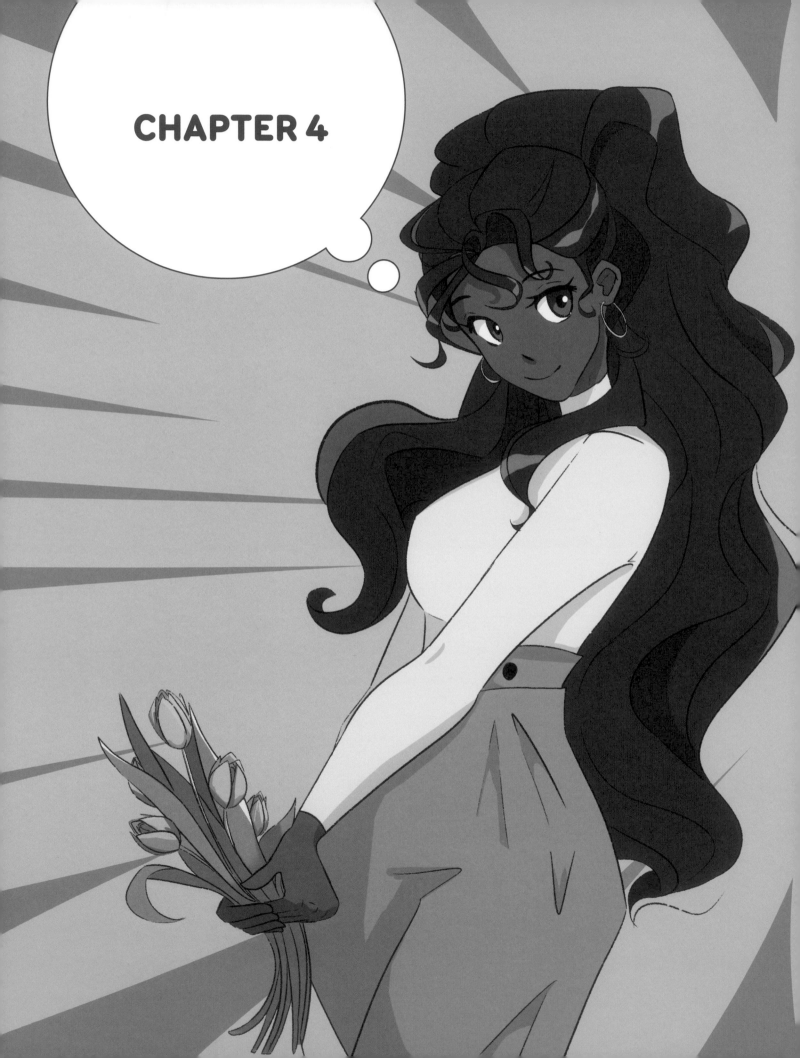

CHAPTER 4

# Hair

This section covers the concepts behind drawing hair, including how to segment the hair to simplify a hairstyle, how to approach drawing braids, and some breakdowns of hair accessories.

Let's look at straight, curly, short, long, shaved, and styled hair types so you can make a wide range of characters.

# Manga Hair: The Basics

Manga hair is drawn as a simplified version of real hair by grouping clumps of hair strands. These groups follow the direction of the hair and the hair section. Let's look at a reference hairstyle to understand how to section the hair and simplify it. This technique can then be applied to all the hairstyles you draw in the future.

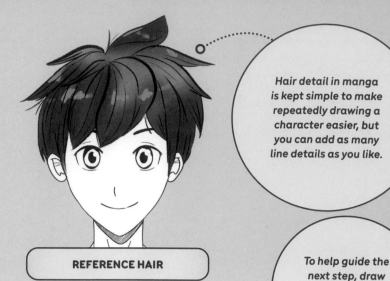

REFERENCE HAIR

*Hair detail in manga is kept simple to make repeatedly drawing a character easier, but you can add as many line details as you like.*

*To help guide the next step, draw a larger circle outside of the head.*

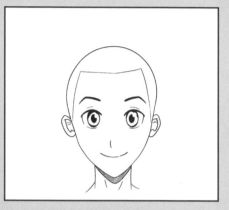

**1** Find and outline the hairline. This is a good guide for drawing the front section of the hair.

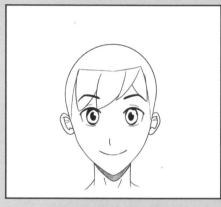

**2** Draw the shapes that form the front section of the hair.

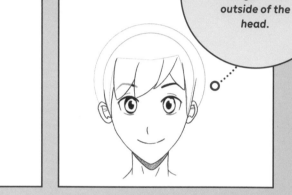

**3** Ask yourself, how does the front section of the hair join up to the next? Give the character bangs, sideburns, or simply more hairline.

*Clump the tufts of hair into general sections. You can do this by looking at the hair direction. Generally, if the hair changes direction, it's probably a new tuft!*

*Thicker linework at the pointy ends of the hair and sides of the hair sections shows where strands overlap.*

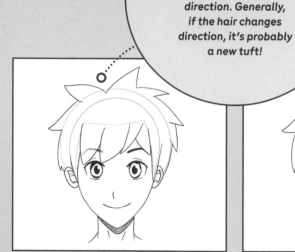

**4** Draw the back section of the hair using simple shapes. Use the large circle as a guideline for where the hair reaches, since hair has volume!

**5** Add lines to the body of the hair to better define where the hair moves in different directions.

**6** Add details such as varying line thickness, shading, highlights, and more lines to hair sections.

Follow the tutorial on this character head. Go over the guideline in the line art stage to finish the sketch.

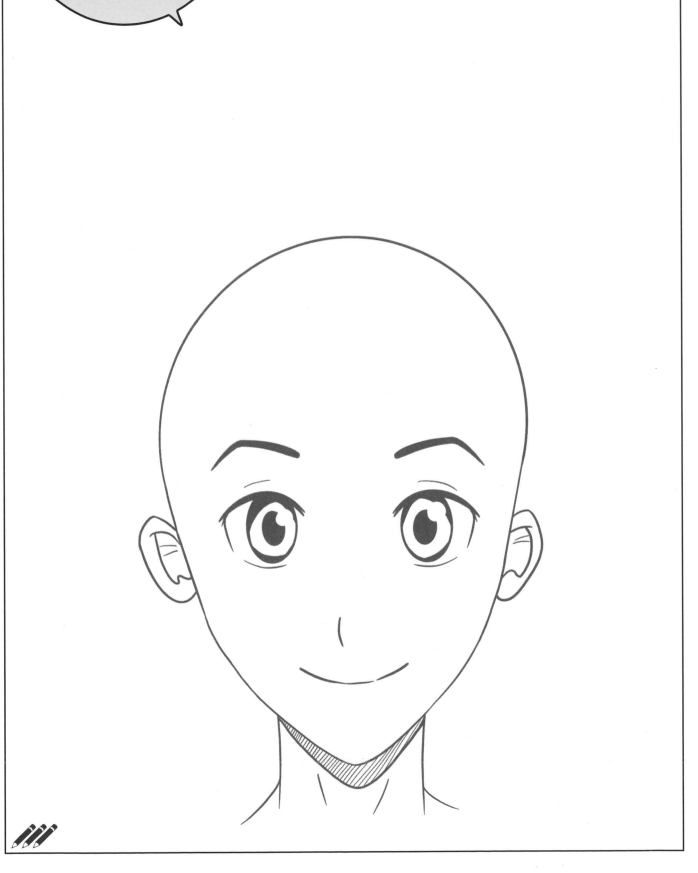

# Straight Hair: Female

Follow these tutorials to draw some characters with straight hair.

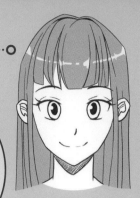

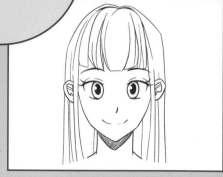

*If you add shading, also add highlights in a circular shape.*

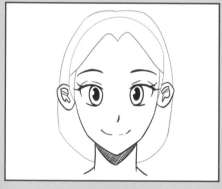

**1** Section the hair.

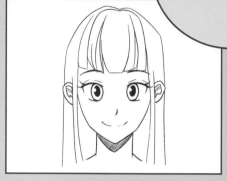

**2** Draw the hair outline.

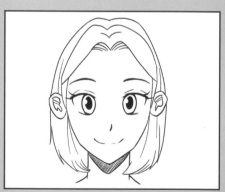

**3** Add hair details.

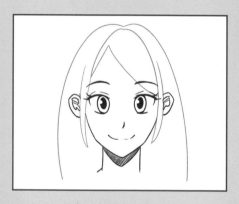

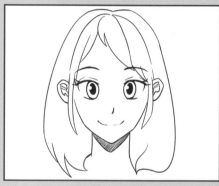

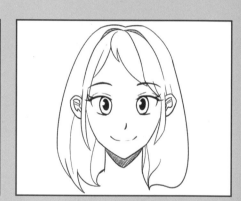

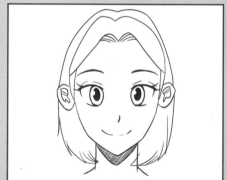

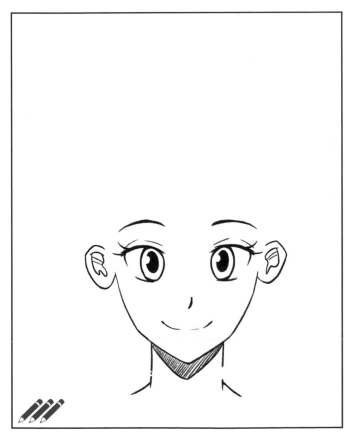

# Straight Hair: Male

Follow these tutorials to draw more straight hairstyles.

**1** Section the hair.

**2** Draw the hair outline.

**3** Add hair details.

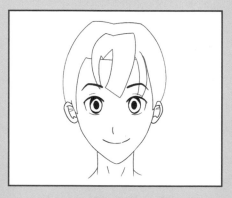

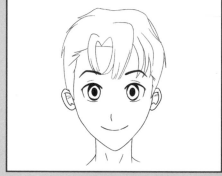

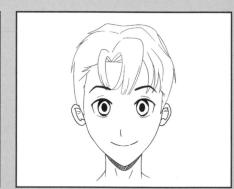

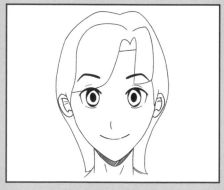

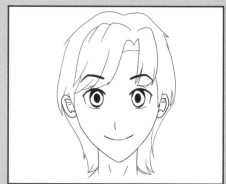

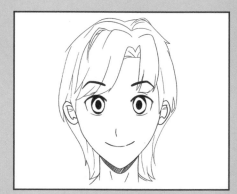

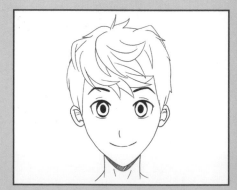

**Try it below!** Practice drawing straight hair in the spaces below.

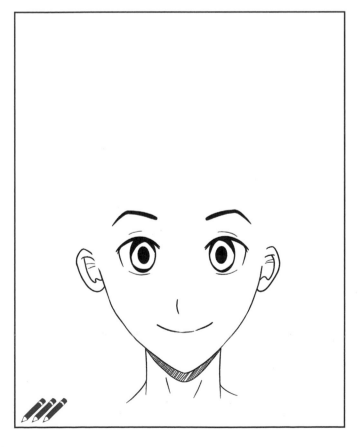

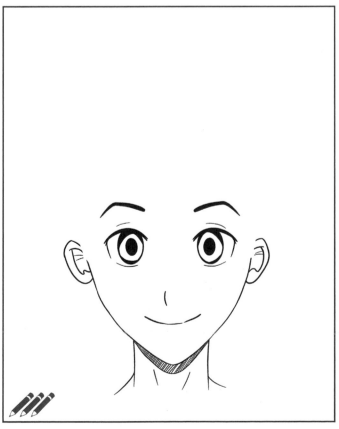

# Curly Hair: Female

Follow these tutorials to draw some characters with curly hair.

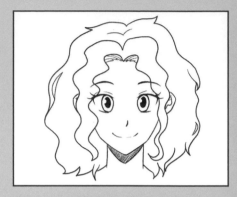

**1** Section the hair.

**2** Draw the hair outline.

**3** Add hair details.

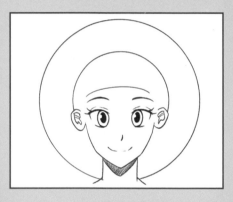

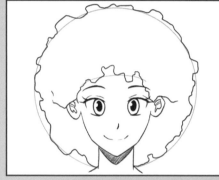

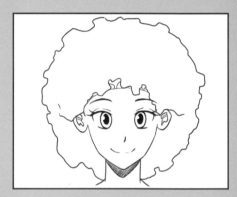

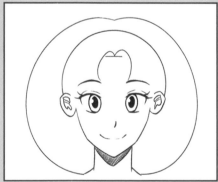

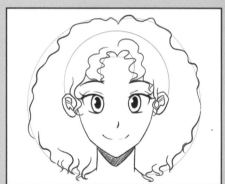

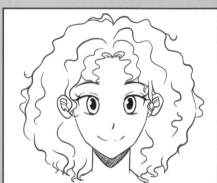

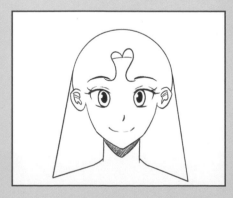

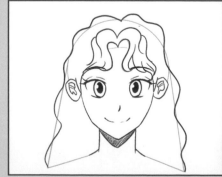

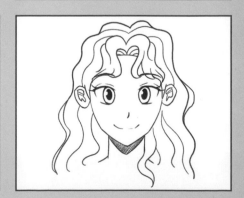

**Try it yourself!**

**Follow the tutorials for curly hair in the spaces below.**

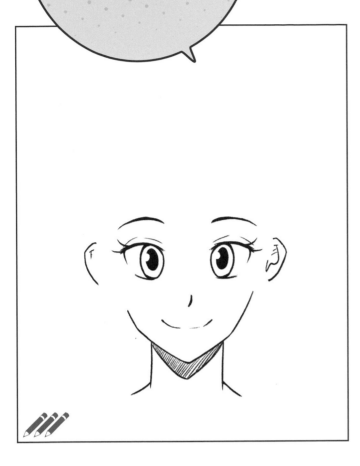

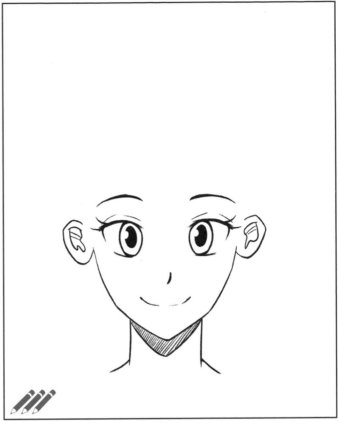

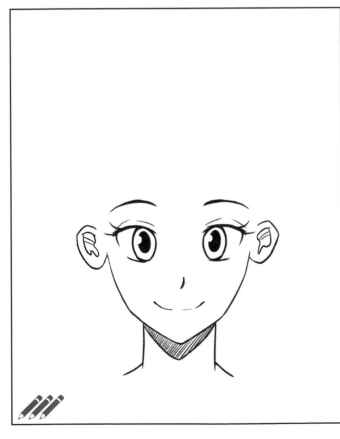

# Curly Hair: Male

Follow these tutorials to learn how to draw more characters with curly hair.

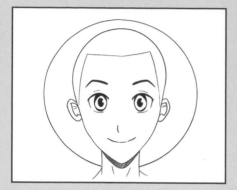

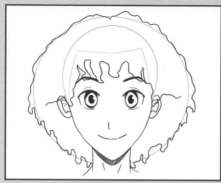

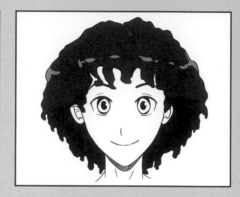

**1** Section the hair.

**2** Draw the hair outline.

**3** Add hair details.

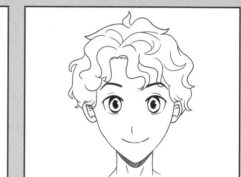

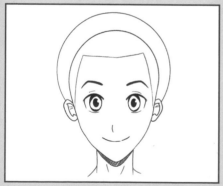

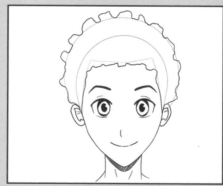

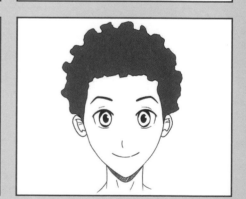

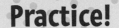 **Practice!** Try drawing these curly hairstyles in the spaces below.

# Styled Hair: Female

Follow these tutorials to draw some female characters with styled hair, including buns, braids, and ponytails!

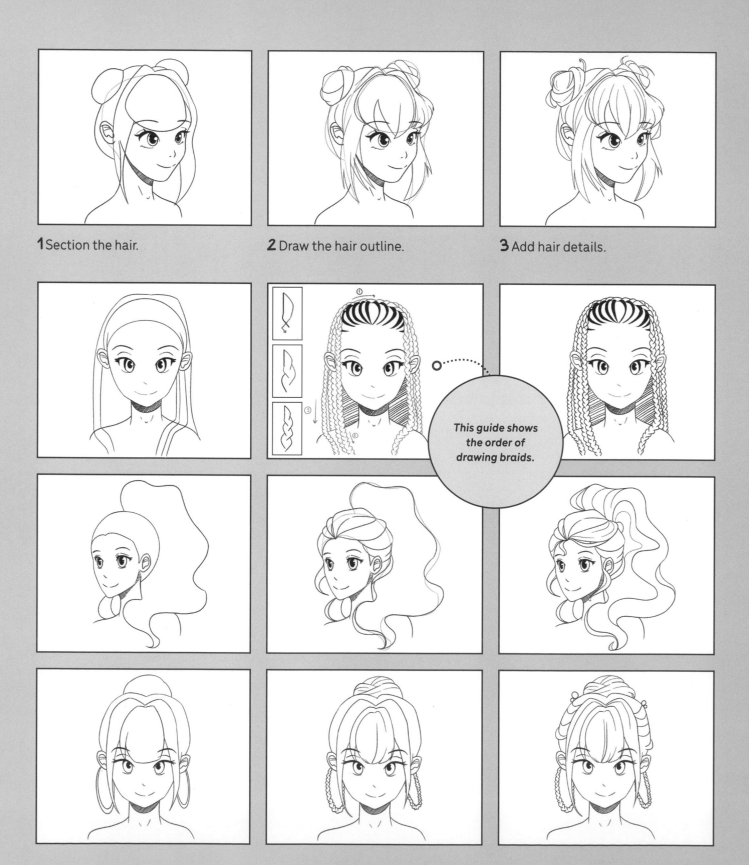

**1** Section the hair.

**2** Draw the hair outline.

**3** Add hair details.

*This guide shows the order of drawing braids.*

**Try it below!** Practice drawing styled hair in the spaces below.

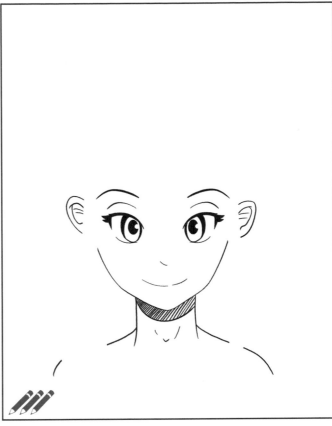

# Styled Hair: Male

Follow these tutorials to draw some male characters with different styled hair looks.

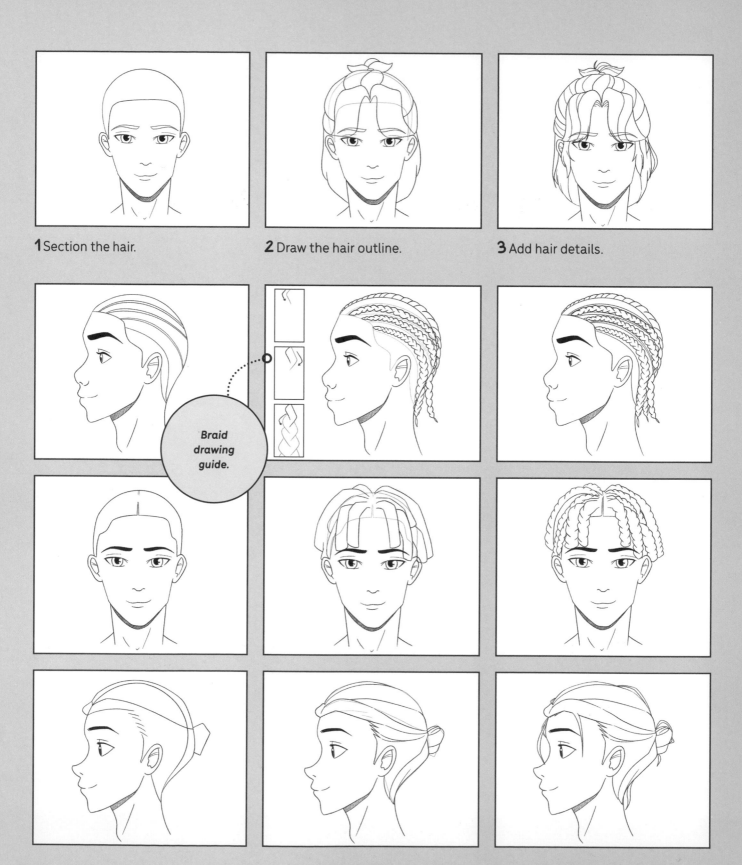

**1** Section the hair.

**2** Draw the hair outline.

**3** Add hair details.

*Braid drawing guide.*

Follow the tutorials for these styled hairstyles in the spaces below.

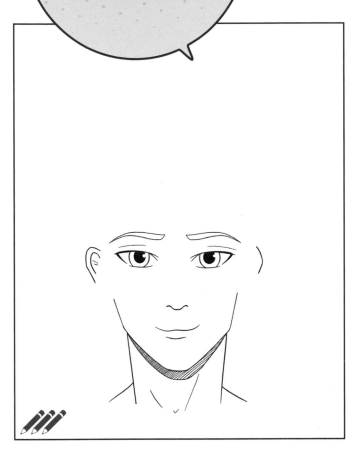

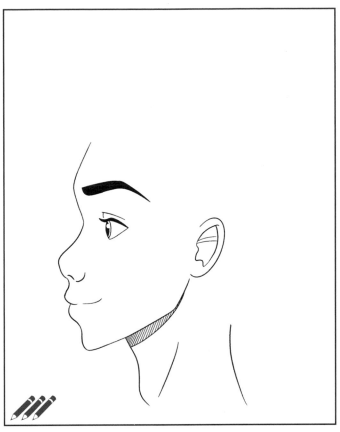

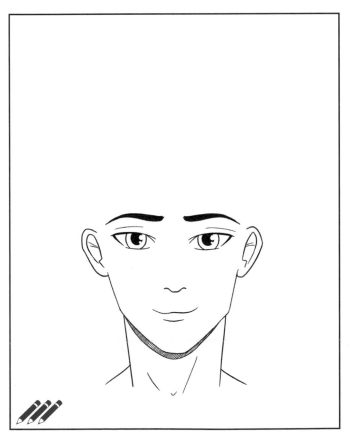

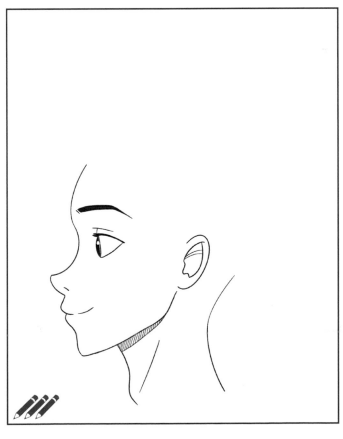

# Shaved Hairstyles: Female

Follow these tutorials to draw some characters with variations of shaved hairstyles.

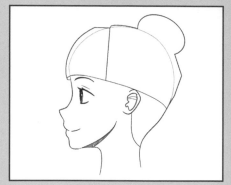 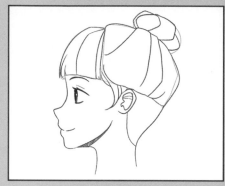 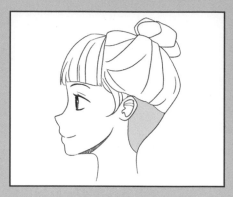

**1** Section the hair.          **2** Draw the hair outline.          **3** Add hair details.

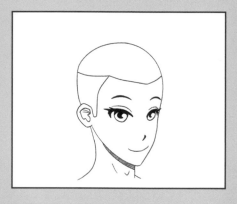  

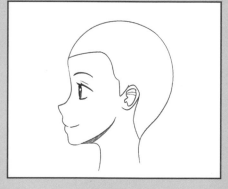 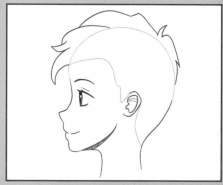 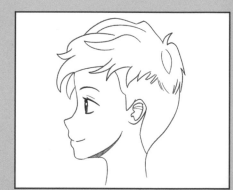

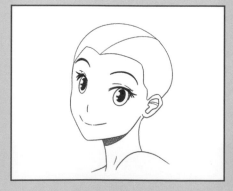 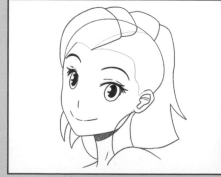 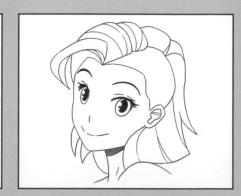

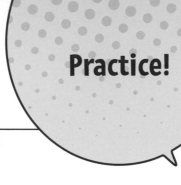
**Follow the tutorials for these partially shaved hairstyles in the spaces below.**

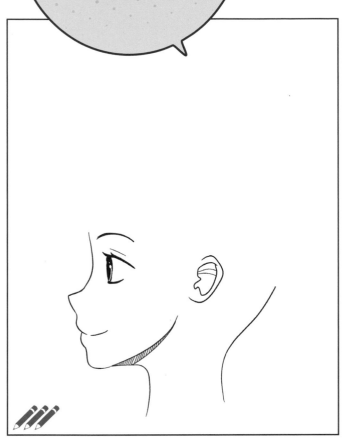

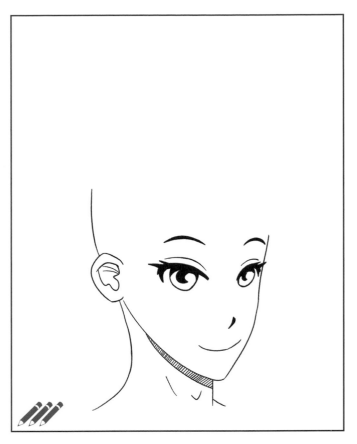

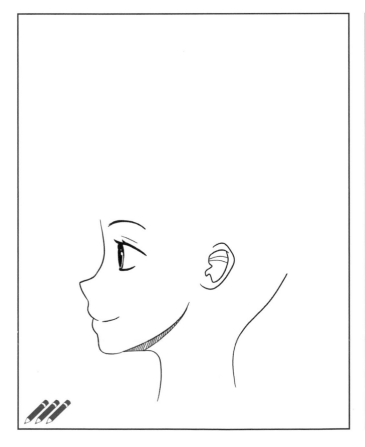

# Shaved Hairstyles: Male

Follow these tutorials to learn how to draw more variations of shaved hairstyles.

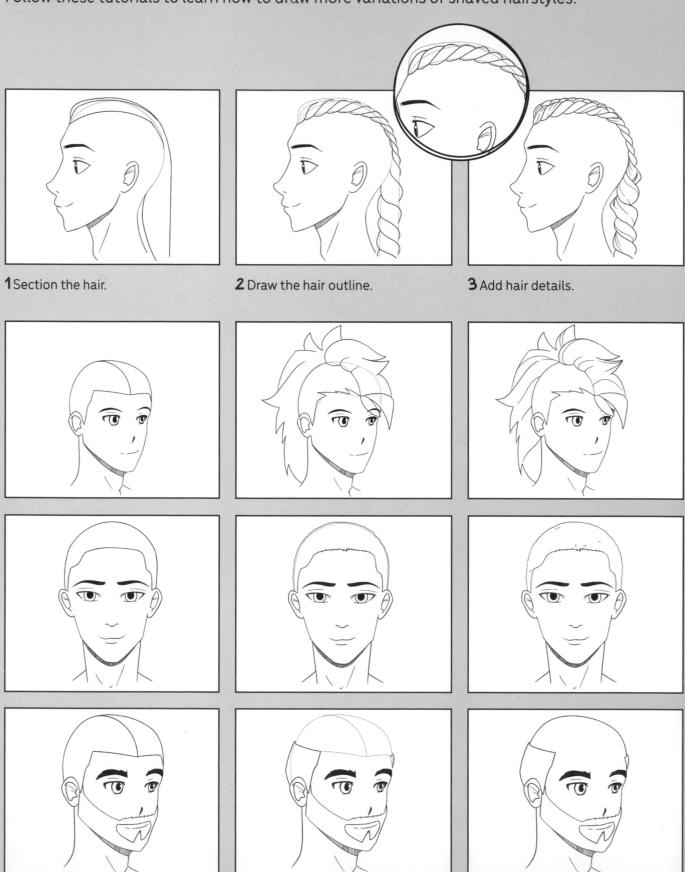

**1** Section the hair.

**2** Draw the hair outline.

**3** Add hair details.

**Try it below!**

Practice drawing these partially shaved hairstyles on the heads below.

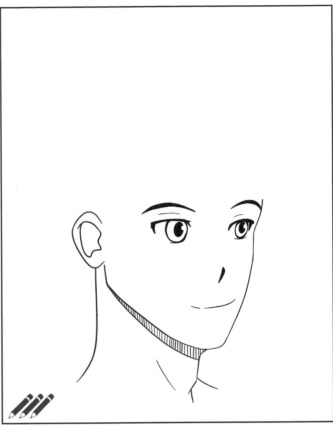

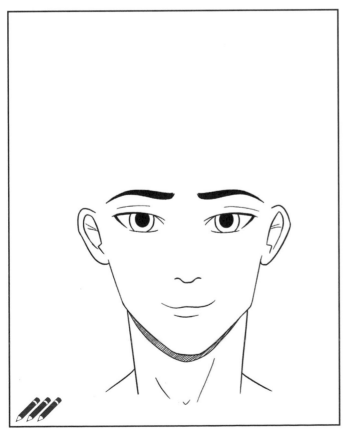

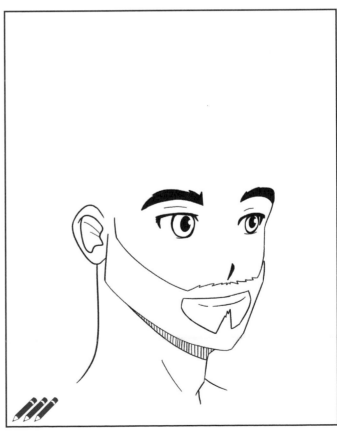

# Hair Accessories

Hair accessories make a fun addition to a character and there are so many options to choose from. They can also be an easy identifier for your character!

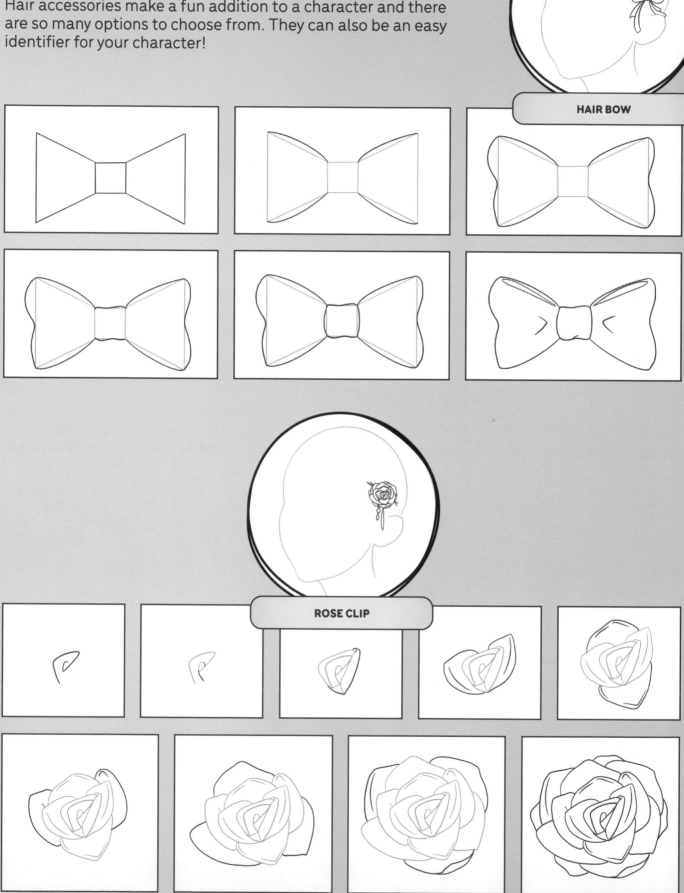

**HAIR BOW**

**ROSE CLIP**

## Try it yourself!

**Practice drawing these accessories in the boxes below.**

# Hair Accessories

CAP

HEADPHONES

ADDITIONAL HAIR ACCESSORY IDEAS

# Practice!

Draw these accessories in the boxes below. You can also copy the extra hair accessories or even come up with your own!

CHAPTER 5

# Put it All Together!

This section combines features from all the previous chapters and gives you the chance to come up with your own characters.

There are some example characters that you can copy to practice your artistic skills too.

It's time to get creative and have some fun using everything you have learned and practiced!

# Example Characters

Try to copy these example characters for some practice at drawing full character heads.

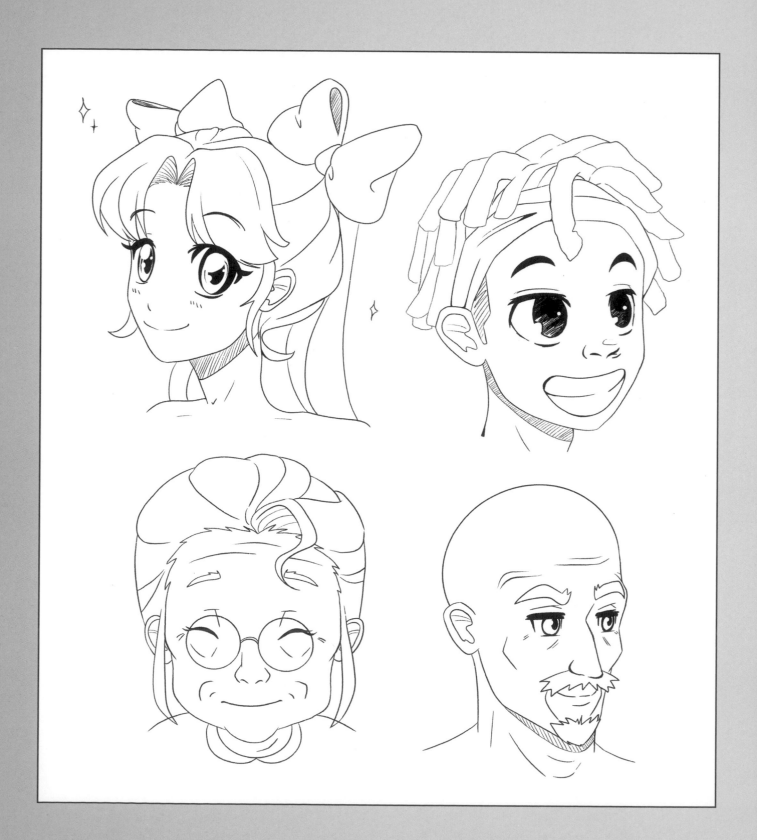

**Try it yourself!**

Use the spaces below to copy the example characters.

# Example Characters

Use these characters as references to practice your manga drawing skills.

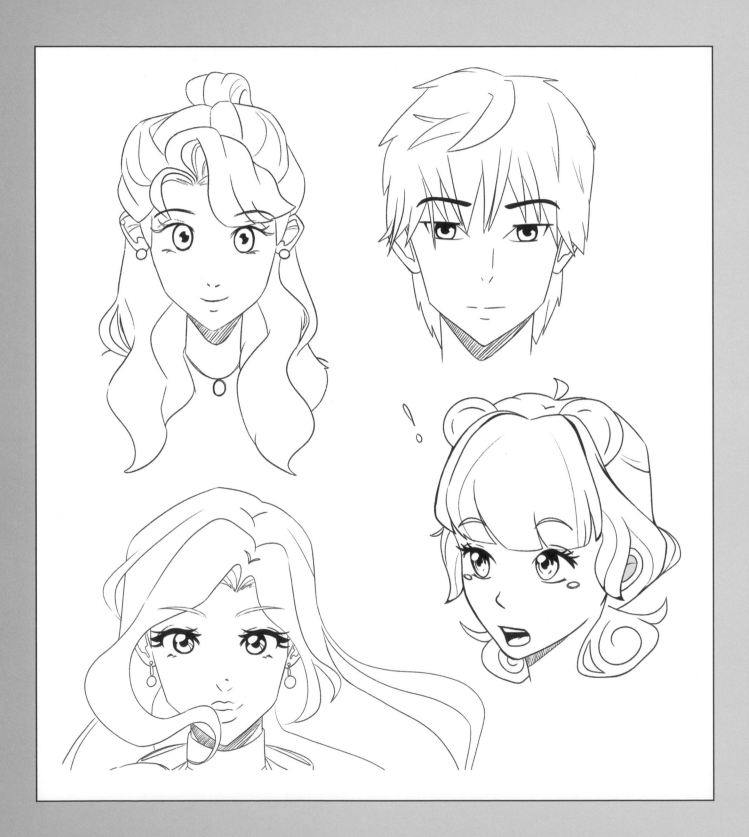

# Practice!

Copy the example characters into the boxes below.

# Example Characters

Here are some example characters for you to copy. You might recognize some of them from the chapter opener illustrations.

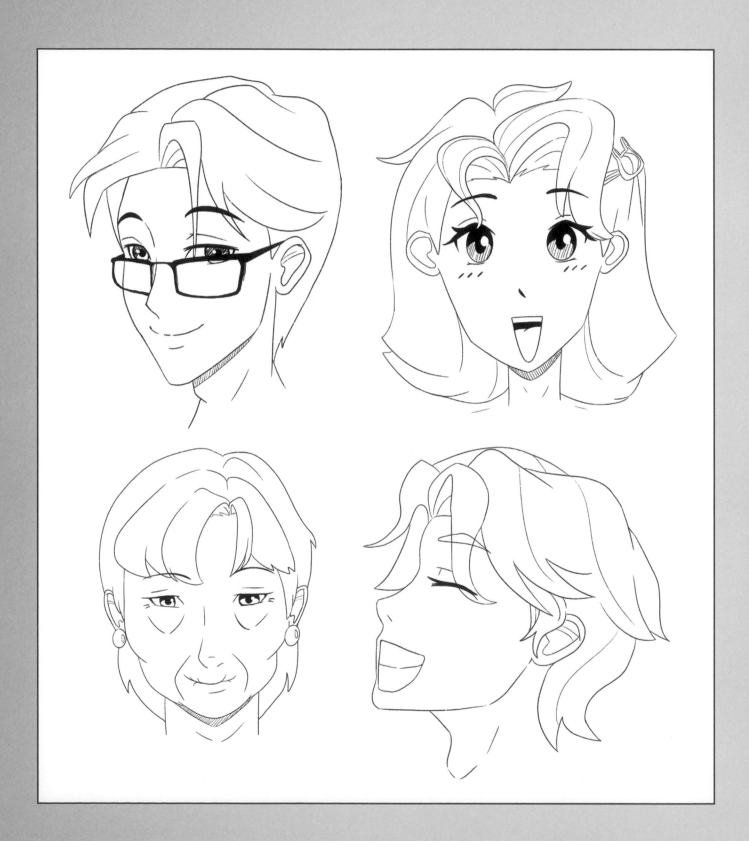

## Try it below!

Use the spaces below to copy the example characters.

# Example Chibi Characters

Here are some example chibi characters for you to copy.

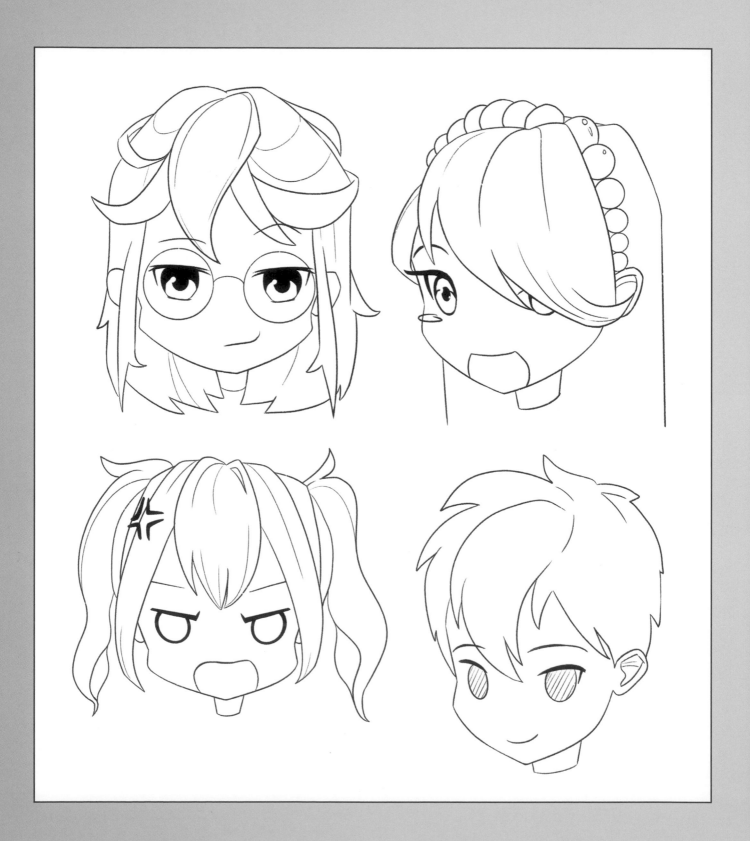

**Try it yourself!**

Copy the example chibi characters in the spaces below.

# Example Character

Draw this character using line art, shading, and color!

**Tip!**
To pick the color palette for your character, test out how the colors look next to each other on a piece of spare paper. Together, do they give the effect you like?

**LINE ART**

*Shading styles in manga vary from cross-hatching to cel shading and from high to low contrast. Cross-hatching involves many lines packed together in parallel or crossing perpendicular to each other. Cel shading (shown below) uses block areas of darker or lighter colors to add the shade.*

*Picking a particular color palette or visual for your character can make them more memorable. For example, this character has pastel pink hair with a pink ribbon.*

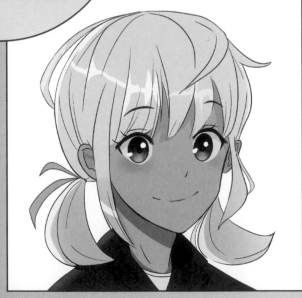

**SHADING**

Use this black-and-white reference to understand cel shading.

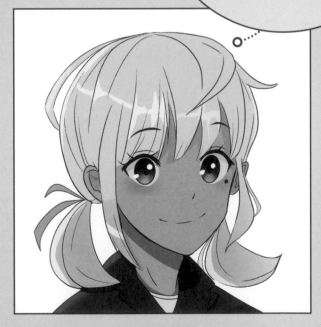

**COLOR**

Use this colored reference for inspiration on how to color the character.

Use the space below to recreate this character.

## Try it below!

A popular exercise for artists is to come up with your own original character, otherwise known as an "OC." Practice drawing your own OC below and on the following pages.

*Tip for creative block!*
*Create a vision board using pictures of people, aesthetics, outfits, or anything else that represents a vibe that you would like your character to reflect.*

*Use these to help you come up with a character design.*

**Draw your OC in different scenarios, expressing different emotions.**

Create friends or family for your OC.

**Create a supporting team for your OC.**

**Create friends or family for your OC.**

**Create a supporting team for your OC.**

## Practice!

For your OC's world, create some characters who would exist in the background.

**Draw a few more background characters in the box below.**

## Try it below!

Redraw your OC as a chibi, each expressing a different emotion. You can use the chibi versions of the expressions on pages 68 and 82 for inspiration.

Draw the chibi here.

Write the emotion here.

**Draw some of your OC's friends, family, or supporting characters as chibis.**

# Practice!

**Recreate some of your favorite movie or book characters as manga characters below.**

**Draw a few more book and movie characters in the boxes below. Write their names in the smaller boxes.**

# Index

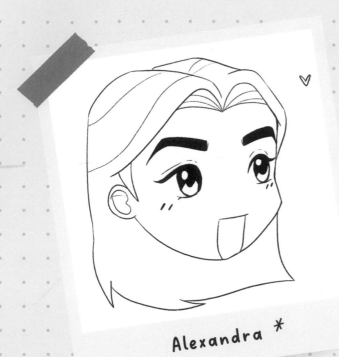

Alexandra *

♥ Martina

☆ Ella ★

## Acknowledgments

The biggest thank-you to Ella, Martina, Lesley, and all of those at Quarto who have made one of my childhood dreams a reality. I am so grateful for this opportunity, which has grown my skills and provided me with the most supportive creative outlet.

Thank you to all my commission customers who have supported me in my journey and are so kind, and to my social media followers for giving me confidence in my art.

Thank you to my family and friends for always cheering me on; Alexandra for inspiring me, and to Louis for always pushing me to go further and for supporting me.